DRAW
Fantasy Figures

DRAW
Fantasy Figures

Gary Spencer Millidge and James McKay

NEW HOLLAND

First published in 2007 by
New Holland Publishers (UK) Ltd
London • Cape Town • Sydney • Auckland

Garfield House, 86–88 Edgware Road
London W2 2EA
www.newhollandpublishers.com

80 McKenzie Street, Cape Town 8001
South Africa

Unit 1, 66 Gibbes Street, Chatswood, NSW 2067
Australia

218 Lake Road, Northcote, Auckland
New Zealand

ISBN: 978 1 84537 753 3

Senior editors: Clare Hubbard, Naomi Waters
Designer: Neal Cobourne
Production: Hazel Kirkman
Editorial direction: Rosemary Wilkinson

Reproduction by Pica Digital Pte Ltd, Singapore
Printed and bound in Malaysia by Times Offset
(M) Sdn Bhd

1 3 5 7 9 10 8 6 4 2

CONTENTS

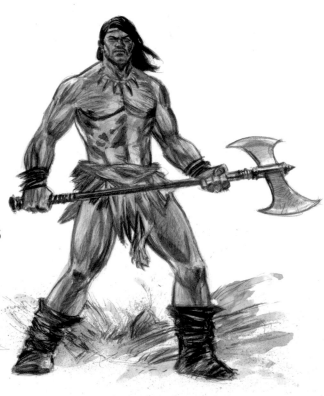

INTRODUCTION

What is fantasy?

Fantasy is a broad description which can mean many different things to different people. In general terms, fantasy is related to the imagination, larger-than-life or dream-like characters and events, usually featuring magic and the supernatural.

More specifically, fantasy is defined by popular literature and films like R. E. Howard's tales of sword and sorcery and Tolkien's arduous quests through Middle Earth. Even as a child, you may have been captivated by Grimm's fairy tales, the Narnia books or, more recently, Harry Potter.

But of course, fantasy is as old as time itself and much of what you might understand as fantasy originated in Norse and Celtic legends, and myths from Greece, Rome, India and Egypt.

Young children and their fertile imaginations have an inherent love of fantasy, and they also love to draw. For various reasons, as childhood grows into adulthood, most lose interest in art and fantasy.

I hope that this book will show you how to regain that youthful imagination and bring your own fantasy characters to life.

Fantasy drawing

Drawing fantasy figures is pretty much like drawing anything else. You need to learn and practise a number of different skills and techniques and employ them in unison to create works of art. You should ideally take an interest in anatomy and perspective, in drapery and landscapes, in lighting and colour. But unlike other 'normal' artists, you need to take your art one step further – into the exaggerated, magical, larger-than-life world of fantasy.

Just because it's fantasy, you shouldn't rely on just pulling stuff out of your head. You can do that as well, but as I will reiterate at regular intervals throughout this book, your art needs to be based in reality in order to be convincing.

Learning the correct rules of anatomy will enable you to transform the human body into mythical creatures like elves and orcs, hobbits and trolls which remain believable, despite being utterly incredible.

Understanding the laws of perspective will allow you to create images of floating castles and sprawling alien villages that look plausible, and yet cannot exist in the real world.

Just because your art is grounded in reality, doesn't make it less fantastical. In fact, you will see that creating your own fantasy characters and the worlds in which they walk can be greatly enhanced by the knowledge that is contained in this book. Sometimes your drawing will look 'wrong,' but by learning the absolute basics, you can begin to understand why it's wrong and figure out how to correct your mistakes.

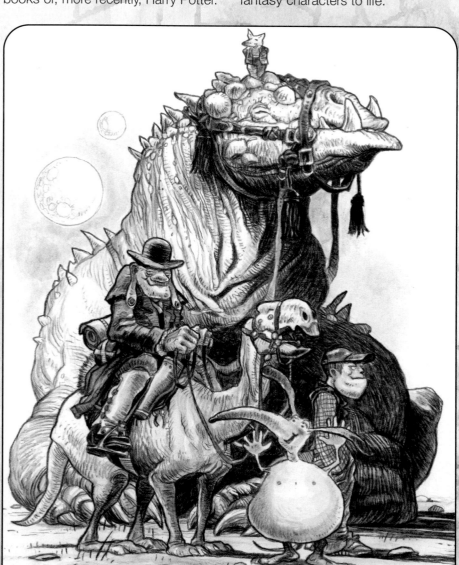

Starting your journey

There will be a number of themes that I will return to throughout this book. To improve as a fantasy artist, practise is the key. Keep sketchbooks and draw. Draw to practise, not to create finished works of art straight away. Keep an open mind and experiment. Try out new styles, dabble in new techniques, test out new media, search for inspiration in new places. Keep drawing and learning and don't be afraid to mess up. It's by making mistakes that you truly learn.

During the course of this book, you will learn about the materials and equipment you may need,

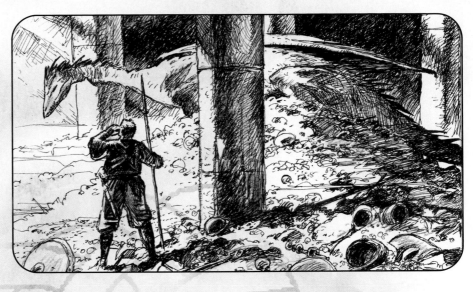

techniques you can use and the basic rules of anatomy, perspective, scale and lighting. But also you will be given step-by-step tutorials in creating your own fantasy figures,

and tips and ideas for putting together your own convincing fantasy worlds. As you acquire more skills, you will be able to create ever more complex and complete scenes.

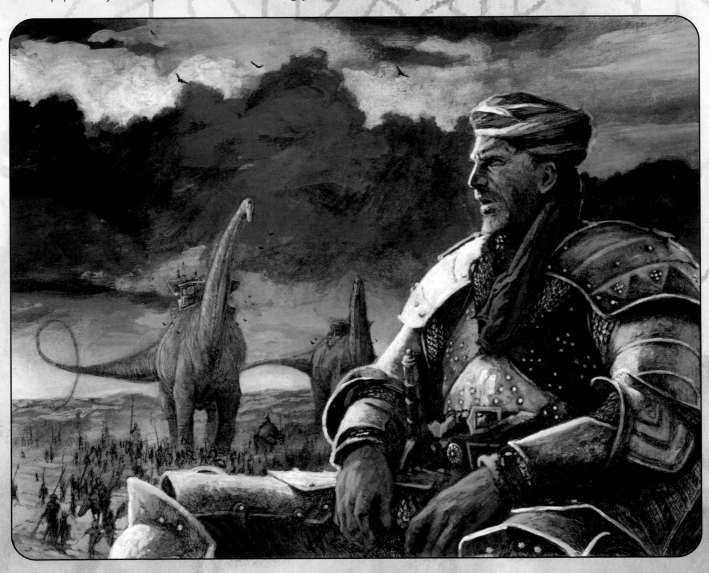

TOOLS OF THE TRADE

The very best artists can produce stunning fantasy panoramas with nothing more than a ballpoint pen and a scrap of paper. But not everyone is so lucky.

Becoming a great artist takes many years of dedicated practice and focus with all kinds of tools and equipment in a wide range of styles and methods.

So, before you go rushing headlong into drawing fantasy figures, you should first think about whether you have the right equipment to create the sort of image you are trying to achieve.

You don't need to have the very best or the most expensive tools available. You don't need to have a huge store cupboard of every drawing and painting supply known to man. It won't magically make you an accomplished artist overnight, but learning to use the appropriate tool for the job can go a long way to making your experience more productive and enjoyable.

Drawing environment

You don't need a professional drafting table or even an easel (although both are handy). What you do need is a firm, flat and stable surface on which to draw. A sturdy table or some kind of board is fine. Many artists prefer to draw with the surface at an angle, and this can also help with your posture.

Good lighting is important to help prevent eyestrain. If you're right handed, light is best coming over your left shoulder (and vice versa). The light source can be from a bright window, room lighting, or better still, an angle-poise lamp.

Papers and boards

If you are just starting out, it's best that you use inexpensive paper; otherwise you may feel too 'precious' about the surface and won't relax properly when drawing. Cheap photocopy or inkjet paper is fine for sketching out ideas and preliminary drawings. Layout paper is also good for sketching and tracing.

Cartridge paper is commonly bought bound in pads of varying sizes and makes a great general purpose surface for pencil, ink and watercolours.

Bristol board is available in sheets or pads and its surface is best suited for inked drawings. This board isn't recommended for wet media, like paint or ink washes. Watercolour paper and boards are usually textured and resist puckering.

There are also a wide range of expensive art boards available, with specialist surfaces for line, wash and watercolour; these are entirely rigid.

For oil and acrylic paintings, you might need canvases or canvas boards which can be very costly and are recommended only for the advanced student, although canvas papers are also available.

Pencils

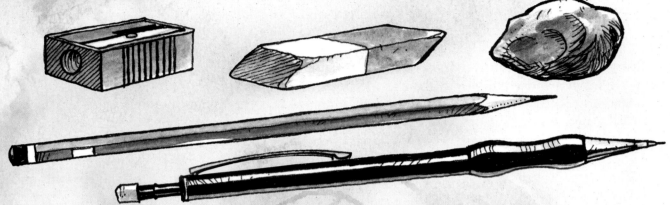

Pencils are probably the most ubiquitous of all drawing tools and that's because they're simple to use, easy to erase and cheap to buy. There are many different grades available, from 9H (very hard) to 9B (very soft). The softer the pencil, the darker and thicker the line and the easier it is to erase. It's also easier to smudge, so with lots of sketching, things can get messy. Artists typically use mid-grades like HB or harder for sketching. Softer grades are excellent for shaded tones, but you might need to use a spray fixative to protect your finished drawing.

You can also purchase mechanical, 'propelling' pencils, which come with separate leads that do not need sharpening, but you may prefer to use the sharper point of a regular wooden pencil.

Blue pencils (some times called 'non-repro blue') are also available. These are excellent for sketching initial layouts as the blue plastic 'lead' does not smudge.

Sharpeners and erasers

You can use regular pencil sharpeners, buy an expensive electric one, or shave your pencils to point with a sharp knife or even sandpaper. See which works best for you.

Plastic erasers are cheap and effective, but many artists prefer to use kneaded 'putty' erasers which can be shaped and used for blending as well as erasing.

Pens

There is a huge variety of pens available from your local arts-material supplier. These range from traditional 'dip' pens (i.e. metal nibs with a split tip) through to fineliners and hi-tech permanent markers.

Dip pens are initially more difficult to use and constantly need to be dipped into a receptacle containing India ink. But this type of pen can give a variation of line widths in the same stroke and is the choice of many professional comic-book inkers and cartoonists. There are also cartridge-fed fountain pens and calligraphy pens which can achieve similar results but do not require dipping. Technical pens also contain a reservoir of ink, but are only capable of producing one line width (although many different tip sizes are available). These are best used for ruling straight lines, lettering, background detail and textures.

Modern fibre-tip pens such as fineliners, brush pens, roller-ball pens and markers can be bleed-proof, waterproof or permanent and are available in a range of tip sizes. They are also very convenient and quick to use.

Ink and brushes

Black ink, or India ink, used for quill pens and brushes should always be waterproof or permanent. The ink can be thinned using distilled water or thickened by simply leaving the cap off overnight.

Using a brush to apply ink can be more difficult to master than a pen, but can give more fluid and expressive results with practise. Experiment to see what works for you.

Sable brushes are the best, but are more expensive and ink can rot them if they're not cleaned properly. Synthetic fibre brushes are cheaper, but be careful to choose brushes with a good point.

These types of brushes can also be used to apply watercolours, coloured inks and gouache. There is a wide range of coarser brushes available specifically for use with oil paint.

Paints

You will find a wide variety of paints available in a huge range of colours, but the main ones are watercolour, gouache, oil and acrylic.

Watercolour is quick to apply and its transparent nature lends itself to subtle tones and bleed effects which can be achieved by layering. Gouache is also water-based, but is more opaque.

Oil paint takes several hours to dry, is quite pungent and subsequently takes some time to master. You also need oil-based thinners and white spirit for cleaning

brushes. However, it's easier to blend the paint 'wet-edge' style and colours are more vivid. This is the choice of the fine artist.

Acrylic paint gives a similar-looking end result to oil paint, but as it is water-based, it takes much less time to dry and is usually the preferred choice of the commercial artist; something to consider from a professional perspective.

You may also need a palette to mix your paint and some jars containing water for washing your brushes.

Other media and equipment

There are many other ways to make marks on paper. Coloured pencils, Conté crayons and pastels can create a softer, more delicate image. Using charcoal sticks on textured art paper also gives a distinctive result.

'White Out,' is an opaque white paint which is used for corrections to ink or for adding highlights. Masking fluid can be painted on to shield areas prior to painting and then removed to reveal highlights.

Transparent coloured inks sold in small bottles are only available in a limited number of colours, although they can be mixed together and applied with a brush over line drawings to great effect.

Professional graphic designers use refillable 'studio' markers which are very quick to use and are available in a wide range of colours, but are rather expensive. Also, they can only be used on 'bleed-proof' marker paper.

You may also find that you need technical tools like masking tape, rulers and scalpels. The well-furnished studio will also include exotic items like art projectors and plan chests for storage. A particularly useful item is the lightbox, used for tracing. Rather than rushing out and buying high-end equipment, you can make a rudimentary lightbox from an old drawer, a light source such as an old lamp and a sheet of Perspex.

Computers

Many artists now prefer to use computers in order to create their illustrations by using expensive software and graphics tablets to draw directly onto the computer screen, or to create 3D computer models. Most professional artists use computers at some stage while creating an illustration, if only to scan in their artwork when finished. Many others use them for the sophisticated colouring and special effect techniques they offer. But digital art is a subject in itself. First and foremost, you should develop your own natural drawing ability with traditional tools.

Experiment

There are virtually countless ways of making images, and the key word is to experiment. Don't be afraid to play around with a wide range of different materials, but try a small sample to see if you enjoy working with the medium before investing a lot of money in a large number of different items. You can mix every colour under the sun by using just red, yellow and blue, with white and black to lighten and darken (although this takes some skill in itself), so huge painting kits aren't necessary for the beginner.

Always remember that the most important thing is to spend time mastering basic drawing skills with pencil, pen and brush. You don't need anything else to create stunning images.

Further on in the book, I will go into more elaborate detail about the different effects that can be achieved by using these tools.

Building blocks
THE BARE BONES

In order to draw the human figure (or inhuman figure, come to that), you must have some concept of anatomy. It sounds really dull, doesn't it? But if you're going to distort the regular human physique into heroes and monsters, you need to understand a little about how the bones and muscles of a normal human hang together. You don't need to learn the name of every bone and muscle, but spending a little time studying anatomy will help to inform and enrich your drawings.

There are many excellent books devoted solely to the subject of human anatomy for the artist and there isn't space to go into great detail here. But take a minute to look at the skeleton and muscles.

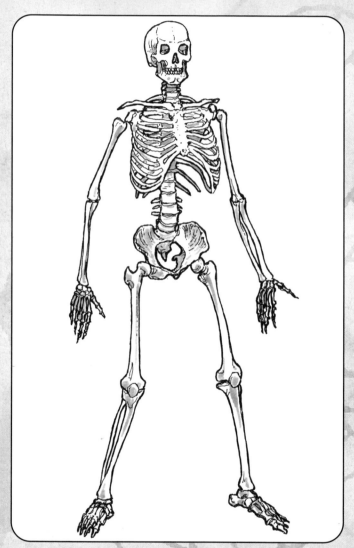
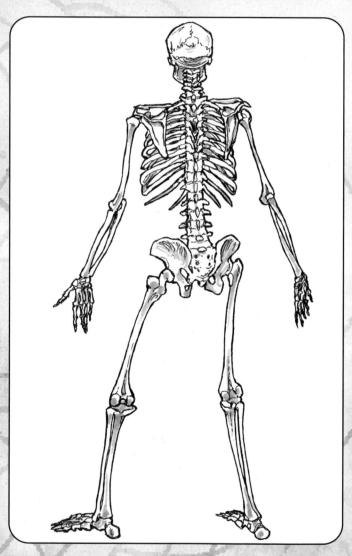

The skeleton ▲

It looks a bit daunting, doesn't it? But don't worry, as you can quite easily break the whole skeleton down into a few basic parts.

Running down the centre of the skeleton, you have the spine, which holds the whole body together. At the top is the skull, then there are a few vertebrae which comprise the neck and the collar bone (or clavicle), and below that the bulk of the ribs. The arms

(consisting of the upper arm, forearm and hands) hang from the shoulders just below the collar bone. A little over halfway up the length of the body, at the bottom of the spine, is the pelvis which defines the hips and waist; and from the pelvis hangs the legs (including the thigh bone, shin bone and feet).

There are a lot more bones in the skeleton than that (just look at the amount of bones that go to make up a foot), but that's enough to work with for now.

The skull ▶

The skull isn't just the basis for every drawing of the head you will ever draw, but is also a dramatic object in itself, often seen adorning sorcerer's tabletops and skewered on the ends of spears. It has only one moving part, the lower jaw.

Learning how to draw a skull correctly will stand you in good stead.

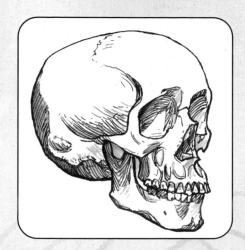
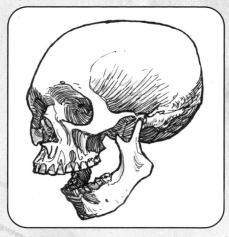

Muscles ▶

Fantasy characters such as ancient barbarians and Viking warriors may have outlandishly large muscles compared to even the most dedicated human bodybuilder around today, but in order to maintain the illusion of reality, some knowledge of where the main muscle groups are located and how they work is extremely useful.

Muscles not only give the human body its shape and definition, but also support the skeleton and the internal organs. Along with the ligaments, the muscles animate the whole body, contracting and expanding to create movement and action.

Take a look at how the muscles connect to the skeleton. The muscles taper at certain points, like the collar bone, spine, elbows, knees, wrists and ankles, allowing for the bones in these areas to show through the skin.

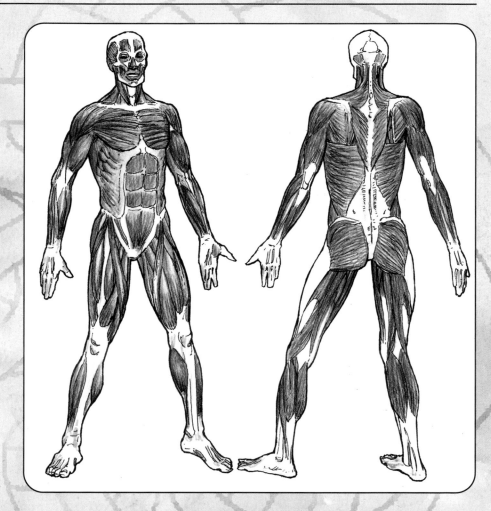

The abdominal stomach muscles (or 'six-pack') and the external obliques to each side hold in many of the internal organs situated under the rib cage. Look at the way the muscles overlap and the power and the movement they imply.

The advanced student will notice that muscles change shape when bodies move. Muscles contract and expand, taking on new shapes when in action. Compare the drawing with your own body, try to find the individual muscles like the bicep on your upper arm and see how they change when flexed.

The skeleton and muscles also limit movement in certain ways, like the knee and elbow joints. When creating a pose for your character, you can always check to see what is possible by using your own body.

You usually can't see all the muscles showing through the skin - sometimes muscle tissue is hidden by layers of fat - which can be almost non-existent in the fittest body, but can have a huge impact on the bulk of the body in overweight figures.

GETTING THINGS IN PROPORTION

Now you can start to draw. Use some cheap paper and a simple pencil to start out with. Sketch loosely and lightly, using many lines, refining your drawing until it looks right to you. Don't be frightened to mess up – you can always erase or start over.

Humans come in all shapes and sizes; dwarves, ogres and giants even more so. But first of all you need to learn the basic proportions of the average human body.

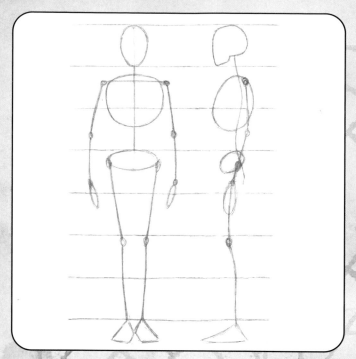

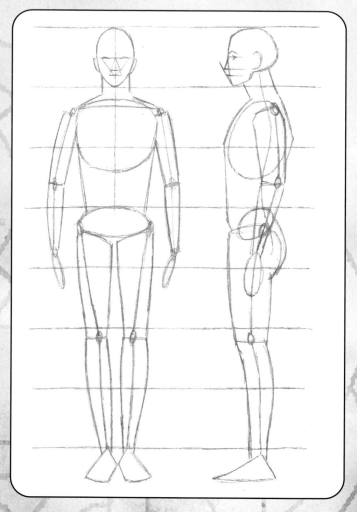

The basic hero ▲

Start with a stick figure to represent the human skeleton. Draw a vertical 'centre line' which will be our figure's spine. The average human body is approximately seven heads high. On paper, this always makes figures look a little stumpy for some reason, so our examples are about half a head taller, at seven-and-a-half heads high.

Draw an egg shape for the head and mark out lines lightly on the page to measure out the figure's height. Now pencil in a flattened circle for the ribcage and another oval for the pelvis – about halfway up the body.

Next, draw the arms and legs with simple lines, small circles to indicate the elbows and knees, and shapes to represent the hands and feet. The legs should be about four heads high, while the upper body is about two.

The elbows fall just below the bottom of the ribcage and the hands reach to about halfway down the thigh. You now have a simple framework (also known as an 'armature') in correct proportion.

From the side, the proportions of height are the same of course, but the shapes differ slightly. The spine curves into a gentle 'S' shape, the ribcage is thinner and the pelvis is tilted slightly. Note the shape of the side of the skull.

Fleshing out ▲

You can now 'flesh out' the skeleton with some simple shapes to represent the layers of muscle and fat that every figure has. It will benefit you as an artist in the long run if you can visualise the human body (and indeed, any object at all) as basic spheres, cylinders, cones and blocks. Once mastered, this will enable you to draw your figures in action poses, from unusual angles, with the correct lighting and perspective.

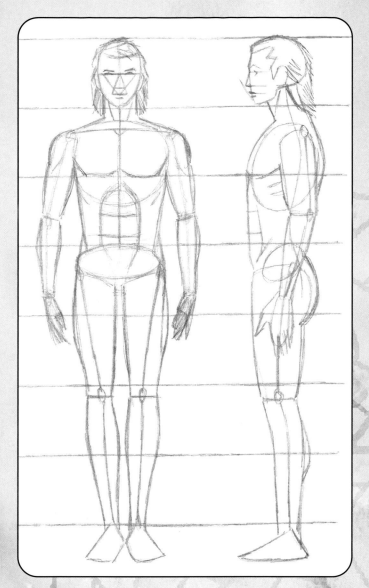

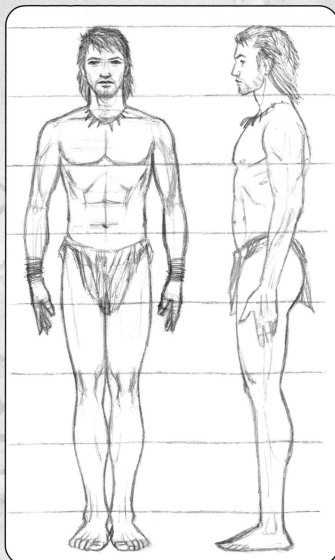

General proportions ▲

Draw over the top of your skeletal armature, adding thickness to your figure with simple rectangles which represent the cylinders and other three-dimensional shapes from which the body is constructed.

Try to look at the figure as a whole as you sketch, rather than concentrating too much on isolated areas of your drawing. It's more important to get general proportions looking right than fine details at this stage.

The right lines ▲

For the final stage, you need to pick out the 'right' lines and darken them. Prepare by lightly erasing your drawing so that you can still see the important construction lines. Use an inking implement such as a dip pen, brush or fibre pen, or if you have pencilled lightly enough, you can use a softer pencil (which will create a blacker line).

Try not to trace the lines too religiously. Use a smooth, flowing movement to pick out the important elements from your underdrawing.

You can add a few adornments such as a loincloth, necklace and wristbands. Eventually, you will have a drawing of a well-proportioned, anatomically accurate figure. Don't worry if it doesn't look exactly right; after all, it's your first attempt. The keyword is practice. It's a boring sounding word I know. But the way to become a great artist (or a great author or great musician or great soccer player) is to keep practising. With practice and an enthusiasm for drawing, you will gradually improve.

The basic heroine

Now try drawing a female character. She will almost always be less muscular, slightly shorter and smaller in bulk than the male. The curves will be softer, and obviously, more feminine.

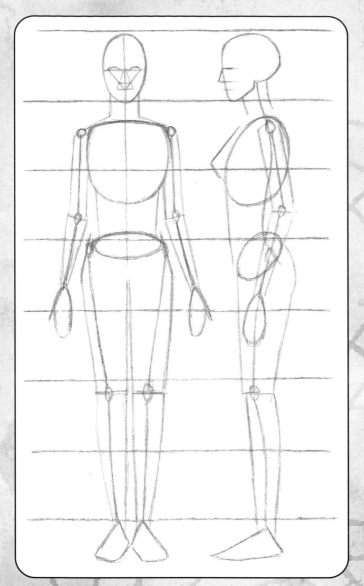

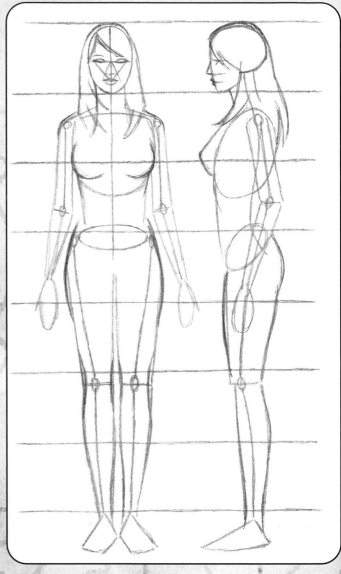

The hourglass shape ▲

The average human female is about seven heads high, but here again you should extend this measurement to about seven-and-a-half heads: Your female armature is going to look pretty much the same as the male, but slightly narrower. Draw your head measurement lines and the centre line. Add the oval shapes to indicate the head, upper torso and hips. Then add the lines for the arms and legs, the shapes for hands and feet.

Add in the blocks and shapes to represent the muscle mass of the arms and legs. Remember that the female is curvier than the male, especially around the hips and the bosom. The waist in particular should be thinner, creating the classic 'hourglass' shape. Female limbs tend to be thinner and more tapered.

Facial features ▲

Start by smoothing your rough outlines, adding initial marks for facial features and indicate hair by drawing it a single mass. Muscles are usually less apparent on the female figure, and remember that the curves are smoother. Ensure that all the basic shapes and proportions look right before progressing to the final rendering stage.

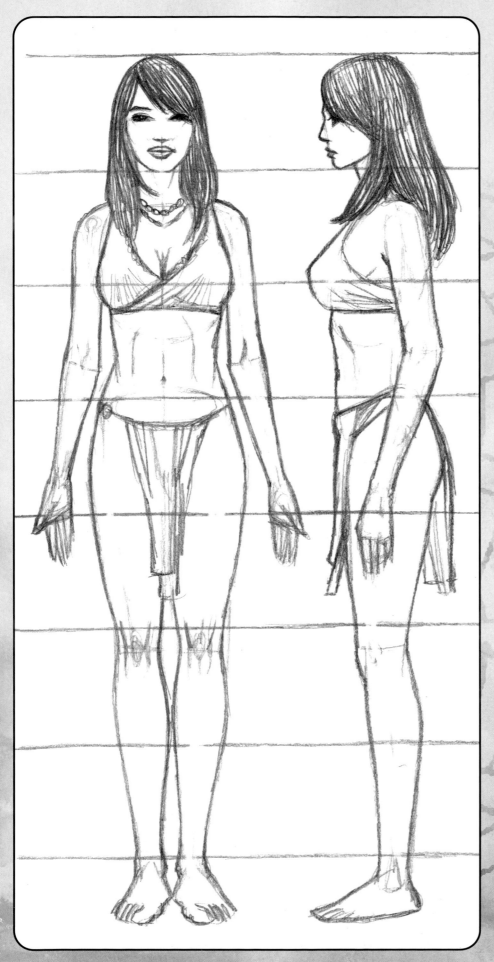

◀ Final details

Finally, erase your rough construction lines and draw in your final outline with a stronger, smoother, tighter line. Notice the definition around the knees and ankles. You can also add detail to the face, hair and add some items of clothing to ensure your heroine's modesty.

This may all seem to be a very long-winded and labour-intensive way of doing things, but as you progress, you will discover that you will be able to 'visualise' the finished drawing in your head and skip some of these stages. But believe me, even the greatest fantasy artists can't pull a completely rendered figure out of their head without at least some form of underdrawing. So, be patient and practise, practise, practise.

DRAWING THE MALE HEAD

Anyone can draw a face. Don't believe me? Draw a circle and inside draw two dots horizontally parallel and a horizontal line underneath. It's a face. The human brain interprets those few simple marks into a recognisable, human face. Drawing a more realistic-looking head is only a little more involved than that; at least, from the front.

Full-face

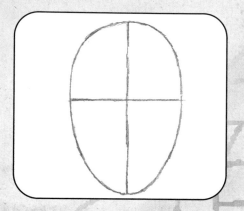

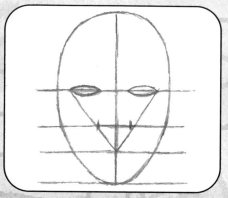

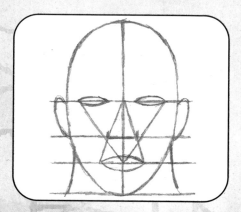

▲ Start by drawing an egg shape, with the tapered end at the bottom. Place a vertical line right down the middle of the oval. The face, like the rest of the body, is essentially symmetrical and this line helps to 'balance' your illustration. Then add a horizontal line just a little higher than the middle of the face.

▲ The human head is about five-eyes wide. Draw the eyes on the horizontal line. The eyes are separated by one eye-width. This also gives you a measurement for the base of the nose. Drawing an equilateral triangle from the outside of the eyes to the centre line will give you the position of the 'mouth line.'

▲ Drawing a triangle extending out from the bridge of the nose to the sides of the bottom of the nose (the edge of the nostrils) and extending to the mouth line gives you the width of the mouth. The ears are placed between the 'eye line' and the 'nose line.' Note that the neck is almost as wide as the head.

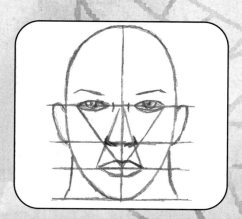

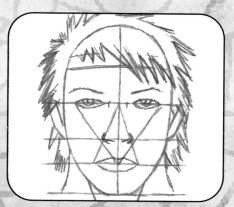

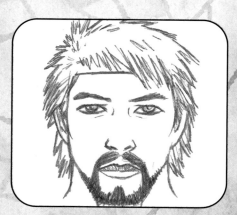

▲ Now it's time to start to add in some real details. Here's where you really start drawing and learning to use your judgement. The eyebrows follow the edge of the skull's eye sockets. Draw in the nostrils. Don't make the lips too full or too dark. Dark lips can make a face look feminine.

▲ Add some hair and we're almost there. Give the hair volume so that it grows out from the scalp. Here, a headband has been added at the hairline. See how the hair flops over the top of the band.

▲ Now's the time to erase all your messy construction lines and do a final render with pencil or pen. Give the eyebrows some body and if you like, add character to the chin with a neat moustache and goatee. And there you have the realistic-looking face of a dashing fantasy hero.

Profile

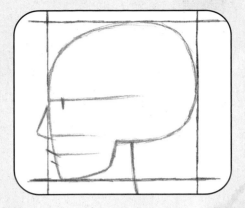

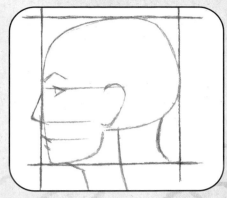

▲ For the side view, or profile, the shape is a little different. In fact, ignoring the nose, the overall shape of the head resembles a square with a chunk missing from the bottom corner. Try to visualise the shape of the skull. Remember that the average proportions of the face will still apply in profile. The eyes are situated about halfway up, the bottom of the nose is level with the base of the skull.

▲ Notice that the eyes from the side look like small triangles with one slightly curved edge. They're set back just slightly from the edge of the face. Add the eyebrow line and the neck. Again, the ears are situated between the bottom of the nose and the eye line. It's interesting that the bottom of the nose, the cheekbone, the bottom of the ear and the base of the skull are on one line.

Three-quarter view

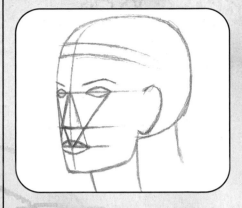

▲ Okay, we're going to up the stakes a little. Here is an example of the face in a three-quarter view. It's almost like the profile, but it's rotated a little. All of the same dimensional relationships apply. This time you have to bend your construction lines along the contour of the shape of the skull. You will get a better result if you can visualise the shape of the head in three dimensions.

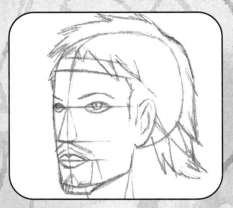

▲ Now start to chisel out the profile like a sculptor. There's a little cutaway under the brow level with the top of the eye; the lips and chin protrude slightly from our guide line. If you study the lines that make up the bottom of the nose, the lips and chin, you may discover that they all seem to be angled at about forty-five degrees from the face and at right-angles to each other.

▲ Now you can lightly erase your guide lines and tighten everything up, adding the final few details to the ears and hair and you have created the perfect profile. Don't worry if your face looks a little different. It's the subtle variations in the relationships between the sizes, shapes and positions of the facial features that make people's faces look… well, different.

▲ Rough in the detail as before. You will need to develop a little more judgement and a good 'eye' to get these other views looking 'right' on a regular basis. Try to visualise the shape of the skull. The depth of the eye sockets, the protrusion of the cheek bones and chin, the angle of the jaw. Once you have worked out the detail, you can lightly erase and draw your finished line.

DRAWING THE FEMALE HEAD

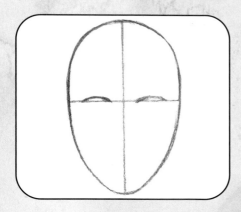

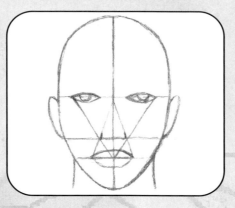

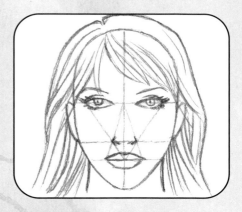

▲ Thankfully, constructing the female head is remarkably similar to the male head, with a few subtle differences. The proportions between the eyes, nose, mouth and ears are all pretty much the same as the male head. Start off with your basic oval - perhaps a little smoother and shapelier than the male's.

▲ Draw in all your little guide lines and triangles in order to place all the facial elements correctly. At this stage, the head could probably still be either male or female. Perhaps the average female face has a slightly narrower nose, larger eyes and fuller lips, but that's about it.

▲ Now you can start to add the more womanly touches: smoother eyebrows, heavier eyelashes and longer, more feminine hair. As with the male, there's no need to draw in the line of the nose – it's unnecessary unless the head is rotated or tilted.

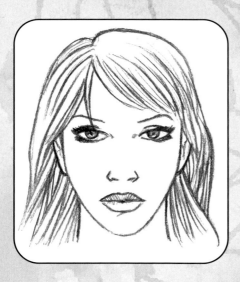

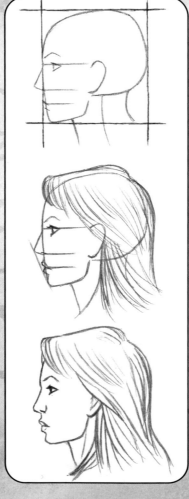

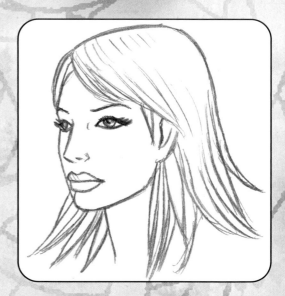

Hair ▲

There's no need to draw in every hair and every eyelash, as this will just make your drawing look scrappy. Try to think of hair as one large shape, with plenty of areas left unrendered. Try to make all the curves less angular and more graceful than the male's. Notice the smaller nostrils and smoother chin. Hey presto! You have created your heroine.

Smooth lines ▲

Again, the female profile and three-quarter views will follow the rules of the male head. Just remember to make your lines smoother and more delicate. Longer and thicker eyelashes are indicated by a single, heavier line. The top curve of the pupil is hidden by the eyelid when looking straight ahead (unless your character is looking surprised). The upper lip juts out further than the lower lip, while the lower is fuller.

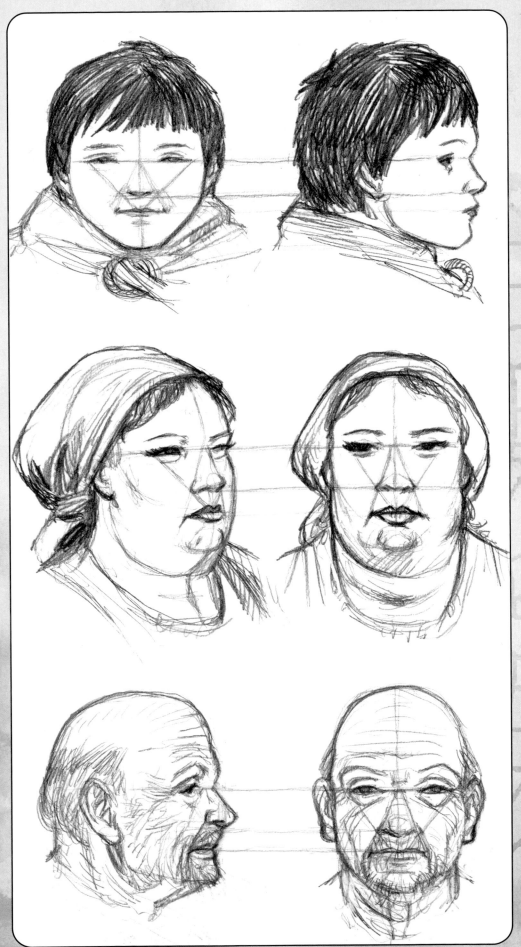

OTHER HEADS

You may not always want to draw perfectly formed, fit young heroes and heroines. You certainly won't want all your fantasy figures to look alike. Here are some examples of different kinds of heads that you may want to try to recreate yourself, by using the techniques shown earlier.

◄ The young apprentice

Children have larger heads in relation to their body compared with adults. The head tends to be much rounder, with their facial features smaller within the head shape.

◄ The chubby maid

Fat under the skin alters the shape of the face considerably. The jowls become larger and wider towards the bottom, the 'double chin' brings the underside of the jaw out onto the neck and fat also forms on the side of the nose and on the chin.

◄ The old man

Unfortunately for all of us, faces tend to gather more wrinkles as they get older. Skin gets baggier and more transparent and men can also lose their rapidly thinning hair. Extra lines form on the forehead, around the mouth and neck, and crow's feet appear around the eyes.

FACIAL FEATURES

You have learned how to construct the basic, average head. But in fantasy, not much is basic or average. Every detail can be altered, exaggerated and distorted for effect.

 Take a look at the examples on the following two pages and practise constructing them. Then you can try to create your own fantasy facial features by further distorting and transforming these examples and others that you may discover.

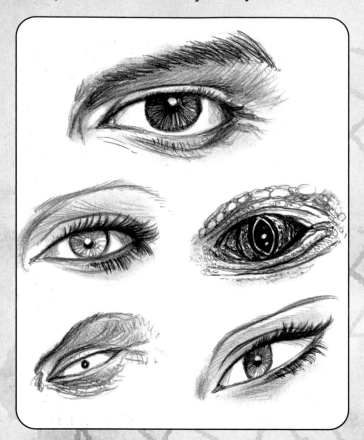

◄ Eyes

The eyes are possibly the most important aspect of your fantasy character's anatomy and they're often the ultimate focus of your illustration.

 Always remember that eyeballs are spherical in shape, and that it's the eyelids that give an eye its distinctive almond shape.

 Small pupils can appear untrustworthy, even evil; while large, dark pupils often appear friendly. Usually, the iris is partly hidden by the upper eyelid, unless your character is surprised. Eyelids covering top and bottom of the iris can give the impression that the eye is squinting.

 Female eyes have more prominent eyelashes and finer eyebrows than male eyes.

 Reptilian eyes tend not to have whites and appear to be rather cold-blooded and evil-looking. The goblin's eye is characterised by the cold, piercing stare of his tiny pupil. Fairies and elves are usually depicted with elongated, slanted eyes.

 Note the small, circular white highlight on each of our examples' pupils. This adds life and suggests shape, and eyes without this glint can look dull and lifeless.

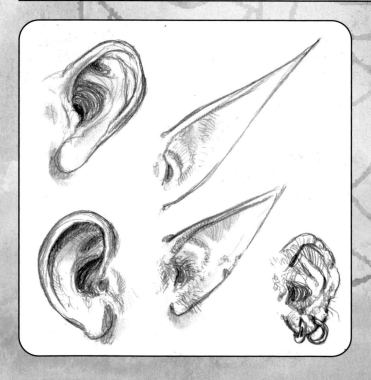

◄ Ears

The human ear is a curious shell-like shape, with numerous twists and folds. In normal lighting, you would draw a strong shadow under the outer edge and in the hollow that surrounds the ear canal. There is also an indentation near the top, halfway between these elements and a fleshy lobe at the bottom. This provides the basic shape for most ears, human, inhuman or animal.

 The ears of goblins, orcs and elves are always very pointed with little or no lobe. Goblins tend to be characterised with much longer, thinner ears, while shorter pointed ears are more typical of orcs. The small, fleshy 'cauliflower' ears of trolls and ogres suggest that they're often in fights.

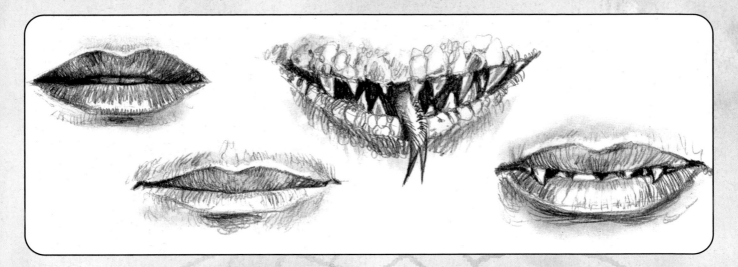

Mouths ▲

Mouths can vary enormously, but they are usually indicated by a pair of lips, top and bottom. The upper lip is characterised by an elongated 'M' shape, while the bottom lip is more of a rotated, flattened 'D' shape. As the bottom lip protrudes further than the top, you should usually indicate white areas to suggest highlights. The bottom lip also casts a shadow directly beneath it in regular lighting situations, giving the lip an appearance of depth.

Female lips are usually more rounded, fuller and darker than a male's lips.

The open mouth reveals teeth, and your fantasy character may have pointed ones, especially if it's a vampire, werewolf or reptilian monster of some description. It might even reveal a forked tongue.

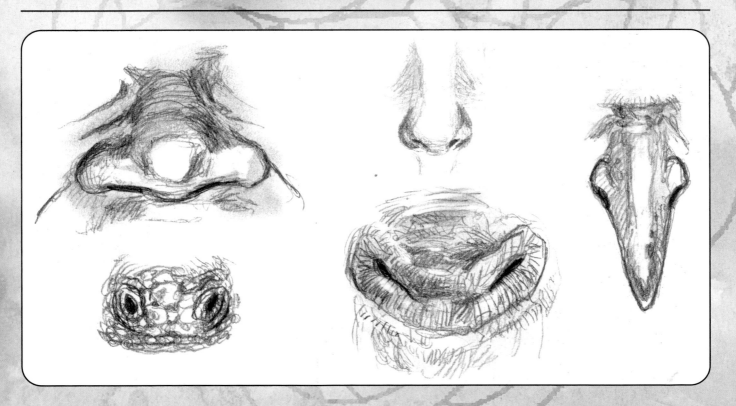

Noses ▲

Just about the only thing that all noses of fantasy figures have in common are two nostrils and the fact that they are found in the centre of the face. Female characters' noses tend to be much smaller and cuter than their male counterparts.

Some noses are simple distortions of the human variety, but wider, flatter and thicker; some are longer, thinner and more pointed.

Other characters' noses may be based on animals' noses, like a pig's snout or a lizard's muzzle, or might incorporate the wide nostrils of an ape-like creature.

HANDS AND FEET

Hands

Hands are one of the most expressive parts of the body. If your figures are to have energy and animation, they should always be using them in some way.

The underlying structure of the human hand consists of many different bones and joints, which makes it notoriously difficult to draw – but fortunately you can get familiar with its appearance and its movement by simply studying your own.

Investigate your own palm, then turn it over and look at the back of your hand and notice how very different it looks from the other side.

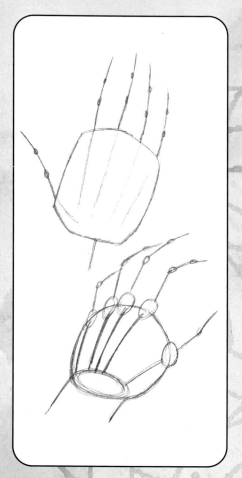

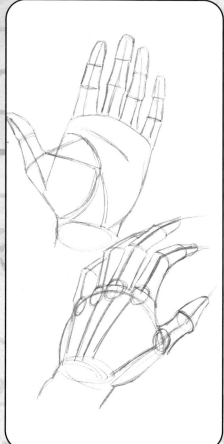

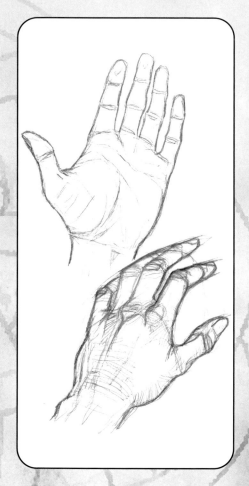

▲ As you have done with the body itself, you can visualise a basic hand by imagining it as constructed from a simplified stick version.

Proportionally, fingers make up half the length of the average human hand. There are three points of articulation for each finger, including the knuckles. Palm-side up, the shape of the hand is basically a rounded-off square. From the reverse, at a slightly foreshortened angle, it can even be represented by a circle. Try copying these examples.

▲ After drawing the skeletal framework of the hand, flesh out the fingers and thumb. The fingers each have three 'segments' which follow the shape of the underlying bones – if you draw fingers as one long sausage shape, they will look fat and puffy. The thumb has an even more prominent shaping, with a wider knuckle and a decidedly convex shape on the endmost segment. Palm-upwards the thumb attaches to the hand from the side, creating a horn-like shape.

▲ Finally, lightly erase your construction lines and draw in your finishing touches. On the underside, the hand is typified by skin creases while on the back of the hand, it's all joints and knuckles.

Because of the hand's dexterity and its characteristic of changing shape when in movement, it is one of the most difficult things to draw. Fortunately, you will always have one with you with which to practise.

▶ Hands can be posed in an almost limitless number of actions and positions: waving, punching, wringing, clapping and grasping to name a few. Note how the position of the fingers and thumb change according to how thick the item the hand is holding. Try copying some of these examples, or better still, draw your own hand in these and other positions.

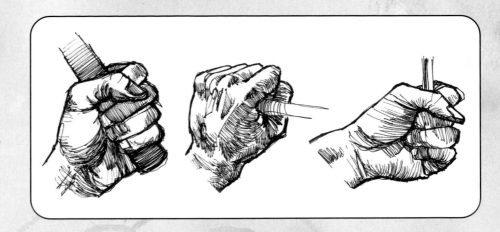

Feet

Feet are easier to draw than the hand in themselves – toes aren't as dexterous as fingers for a start – but they are important in terms of helping your figures look balanced. On many occasions, the feet will be well hidden inside large boots, or behind a conveniently placed piece of shrubbery. But like everything else, the more you understand about the anatomical functions of the feet, the better your drawings will be.

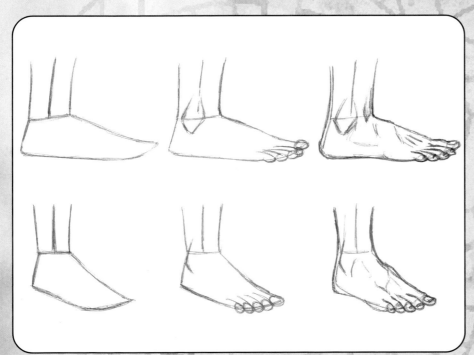

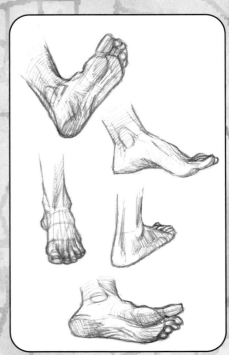

▲ Feet can be visualised as a simple block in many instances – albeit a curiously shaped asymmetrical wedge. Getting the knack of drawing a quick foot-shaped block will be of enormous use to you. Here, the foot is seen in profile from slightly above and at three-quarters.

Try drawing these shapes and then try drawing them again from differing views and angles. As ever, practice makes perfect.

At the next stage you should add in the toes and ankle bone. The ankle is level with the top of the foot block, at the articulation point.

Finally, add in the final detail. Notice that the second toe protrudes the furthest, not the big toe as you may think. Knuckle joints are rather less obvious than that of the fingers.

▲ Feet have much less movement than hands and they only bend significantly where the toes meet the foot. The underside of the foot has a number of interesting bumps and creases – the circular-shaped heel and the fleshy ball behind the big toe being the most prominent.

You can practise your foot-drawing skills by simply taking off your shoes and socks, or asking a friend to.

Bringing your figure to life
POSING THE FIGURE

Putting all the various parts of the human body together and creating convincing poses can be a little daunting. That's why it's always best to start with the stick-figure, or armature – this is essentially a simplified skeleton.

Get your stick-figure to look 'right' and you're halfway there. It pays to get very familiar with drawing these armatures, so that you can quickly create a pose of any kind.

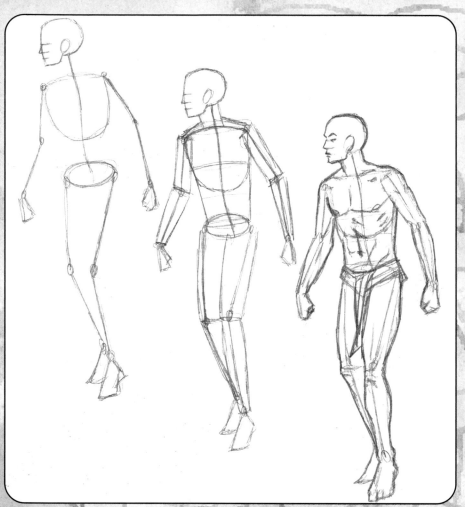

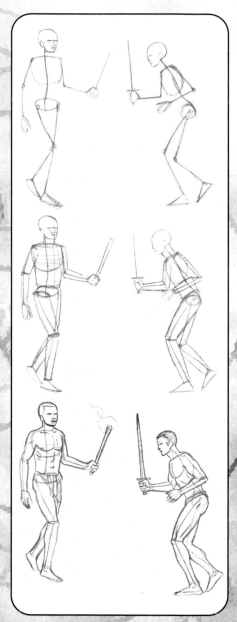

Fleshing out ▲
Starting with the stick-figure on which you practised in the previous chapter, try altering the pose slightly. Here, the character is in motion, taking a small step forward, with his head turned in profile and his body turned slightly away from the viewer.

Once you are happy with the armature, you can start adding the bulk of the muscles, represented in most cases by simple cylinders. This isn't quite as simple as it looks, but as ever, with practice, this skill will soon become second nature.

When you've completely fleshed out your figure with cylinders, you can erase your construction lines (or trace out onto a new sheet) and add the final smoothing and detail. Notice how the right side of his body appears slightly less wide than his left side – compare the width of the chest, for example.

Various poses ▲
Try drawing these example poses of a figure carrying a torch and a sword respectively.

Following the same stages as before, build your armature up into a fully rendered figure.

Reclining figures ▶

A posed figure needn't be in full flow. Here, a character is seated and relaxed. Most of his weight is supported by his backside, but he is also leaning on his left arm.

Once you've mastered these, try to create some of your own.

Remember to keep the figure in proportion – it should be about seven or eight heads high. Think about how the weight is distributed. Does your character look like he's about to topple over? Keep practising simplified skeletons in every pose imaginable until they become second nature to you.

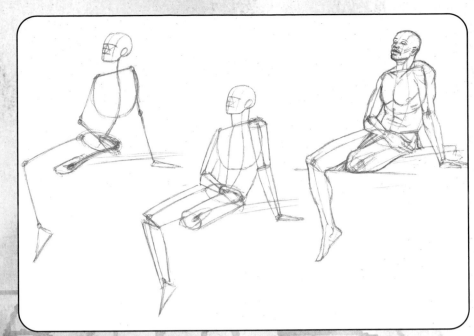

Foreshortening ▶

Foreshortening is also something that should be considered when drawing figures in dynamic poses, from unusual angles or in perspective. When an object (in this case, a limb) looks shorter when oriented towards the viewer, that's foreshortening.

You can demonstrate this with any object, like a book for example. Hold it flat in front of your face and slowly tilt it away from you. See how it appears to get shorter?

Take a look at the tomahawk-wielding character. His right arm has virtually no length as he's holding it out straight, towards the viewer. You can only just see the thickness of his forearm and his elbow, the rest is hidden by his fist. In addition, his left thigh is foreshortened, as the viewer is looking at it end-on. It's not entirely foreshortened, as you can still see part of it, but it appears much shorter than his right thigh.

You will find that with almost every figure that you draw, at least one part will be foreshortened.

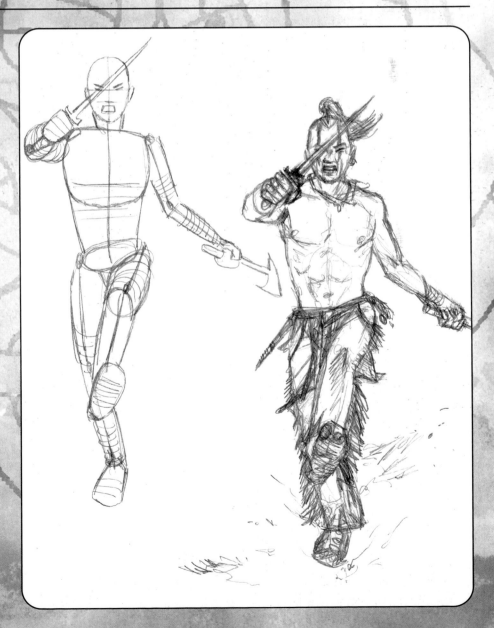

THE ACTION LINE

You won't always want to draw your figures just standing or sitting around. In fact, a lot of the time you will want to create action scenes, with your characters engaged in all manner of energetic and vigorous activities; your barbarian swordsman will want to be swinging his sword dramatically and your wizard will be casting his spells with extravagant gestures. Perhaps your heroine will be riding on horseback or wrestling some fearful monster.

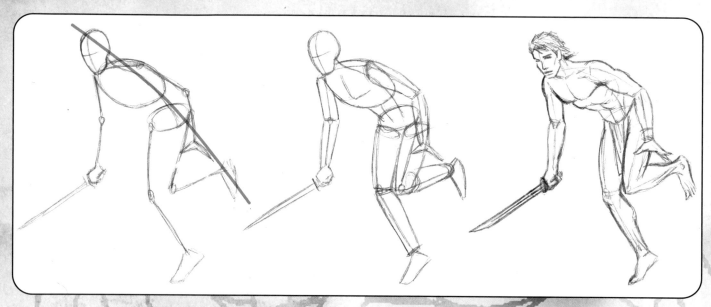

The action line ▲

Start with a stick-figure as before, but this time, try to encapsulate the action you are depicting in one dramatic line. This line is called the 'centre line' or 'action line' and it should convey the essential movement of your character in one sweep of your pencil. This action line provides the basis for your

figure's central spine, onto which you can impose the rest of your stick-figure and its accessories.

Here, this barbarian swordsman is running stealthily, leaning forwards, propelling himself speedily but with a light step. Build your figure as before, starting from the spine and armature, adding cylinders and blocks until you end with your finished figure.

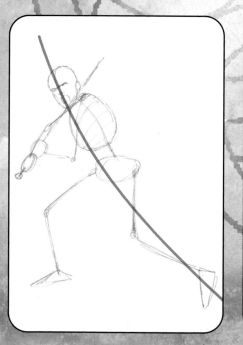

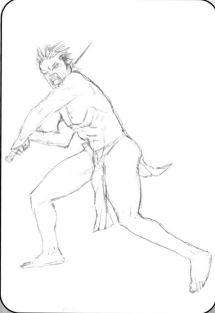

◄ Positioning

You will find that your action line often suggests the position of the head and legs as well. Already, this action line is giving your body more life and energy. Remember, you are creating fantasy figures, so be bold and exaggerate the movement of your characters – make them more dramatic and more dynamic than real people.

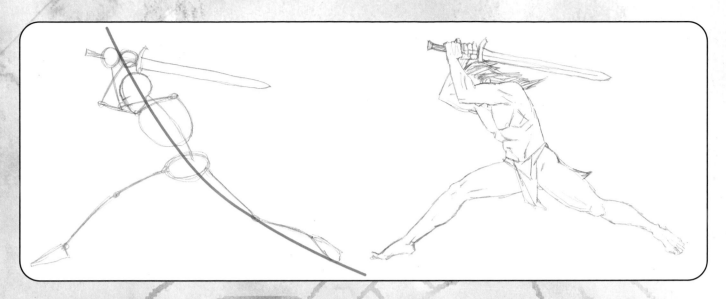

The bigger picture ▲

In this sketch, the line of action follows through the entire body of our character, and also suggests another action is imminent. There is no doubt in the viewers mind that the sword is about to drop. Always try to imply the next movement when you draw fantasy figures. This will add an extra dimension to your pictures, as well as lending tension to the scene that you are creating.

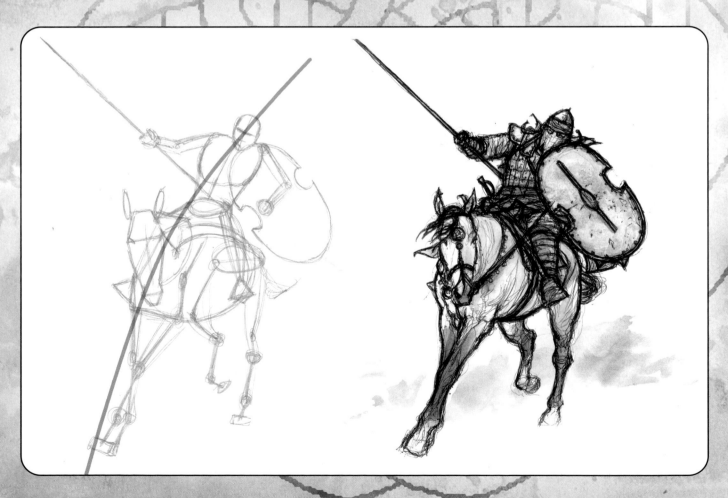

Balance ▲

Here, we can see that the warrior and his steed share an action line – the horse's front legs are a continuation of his rider's spine, even though the direction of the horse is towards the viewer. The action line provides balance and compactness in the picture, with the horseman's spear completing the picture's composition perfectly. Without it, the picture would seem slightly off-kilter.

BODY TALK

Not all your characters will be powerful, swashbuckling superheroes, confidently and assertively fighting their corner, all of the time. To illustrate a picture that tells an interesting story, sometimes you will need to draw characters that are in fear of their lives, resigned to their fate, waiting patiently, being seductively alluring or even laughing heartily.

The 'body language' of your figures, in combination with their facial expressions can describe an enormous range of different and subtle emotions.

When you are sketching your initial skeletal armatures, try to imagine, in relation to your picture, what the characters are thinking, what they are feeling. Are they humble or embarrassed, or alert and confident? You can greatly enhance the interest of your picture if your figures are charged with different emotions, demonstrated by their stance and hand gestures.

Take a look at the examples here. You should be able to recognise the basic emotion from the simple stick-figure alone. Even though the final rendered image tells you who the character is, it's the body posture that conveys the emotion the character is feeling. Triumph, anger, stealth, dejection and fear – they are all just a few pencil strokes away.

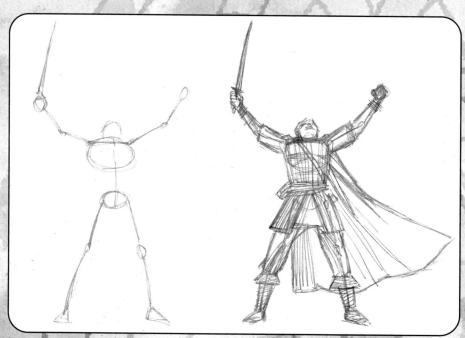

◄ Victory
The victorious warrior at the moment of success; arms aloft, arched back and puffed out chest all signify the feeling of triumph.

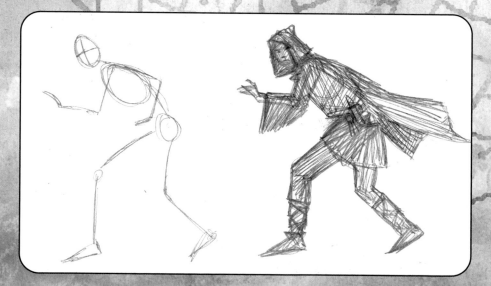

◄ Stealth
This furtive looking chap is creeping around quietly and secretively. The posture suggests he's tip-toeing, arms out to balance himself, carefully sneaking around, perfectly representing stealth.

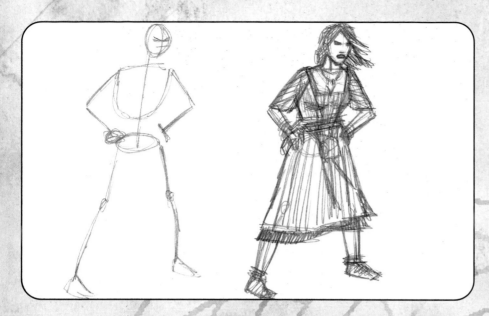

◄ Anger

This figure could be a wife livid with her husband late home from the tavern. A wide stance, hands on hips, upper body leaning slightly forwards implies that you wouldn't want to argue with her. She's obviously fuming with anger.

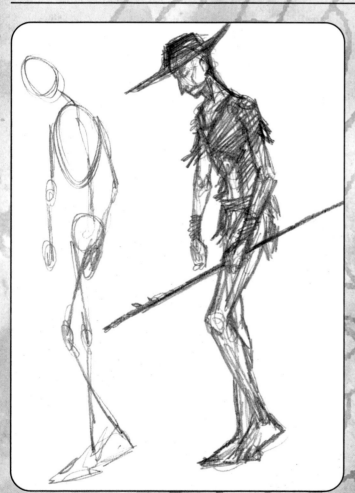

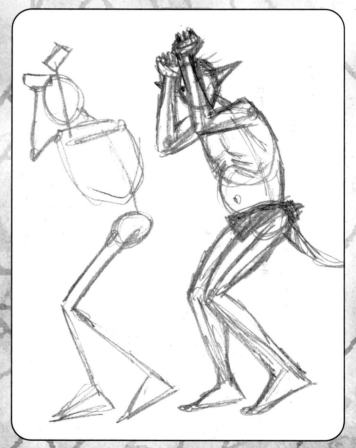

Dejection ▲

This chap looks like a rather undernourished character, down on his luck, and looking pretty sorry for himself. He's obviously sad, fed up and miserable. His thin physique and ragged clothes tell half the story, but the stick figure's slumped shoulders and tilted head alone convey the emotion of dejection.

Cowering ▲

A goblin is cowering in a self-protective pose, knees bent, hands in front of his face, starting to curl up into a ball. He's looking cringing, pathetic, frightened, his posture expressing a specific type of fear.

Now try it yourself. Think of an emotion and try to convey it in a simple stick figure. You can then work it up into a finished character by adding physique, facial expression and clothing.

ALL SHAPES AND SIZES

I have stressed the importance of knowing how to proportion your figures correctly, even if they are not exactly human. You must also consider the relative sizes of different creatures in relation to each other.

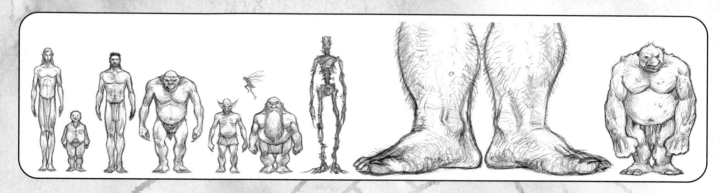

Compare and contrast ▲

Compare all the different shapes and sizes of humanoids in this illustration. They are all based on the same basic skeleton and muscle structure, but the variation in scale and proportion lends a great deal to the character of the figures.

The elf is a taller, more slender version of the standard human male, while the dryad, being composed of vegetation, is even taller and skinnier. The orc and troll are progressively shorter, with thicker, heavier and shorter legs, longer arms, larger heads and hunched postures. Notice in particular how the upper part of the ogre's body dominates his overall physique, with disproportionately large hands, pot belly and positively elephantine feet.

At the lower end of the scale, you have the insect-sized fairy, the hobbit, barely half the size of the human, and the dwarf and goblin. The latter two are similar in height but have very different body shapes; notice in particular how much longer the goblin's legs are in comparison to the dwarf's.

Last, but not least, is the giant, whose name says it all, but the rest of whose body, unfortunately, can't be shown in its entirety.

Opposites attract ▶

In this extreme example, a giant is face-to-face with a dwarf. The size difference is obvious, accentuated by the fact that the giant is bending over in order to listen to what the dwarf is saying. His enormous club suggests he could be dangerous, but the giant's expression is one of bewilderment or disbelief, like a human might look at an unusual insect.

The dwarf, on the other hand, despite his diminutive size, is taking up a much more aggressive pose, feet apart, stepping towards the giant, wagging an accusatory finger at him. Both may have weapons, but neither seems likely to attack at this point, although one suspects that there may be trouble ahead. The overall effect is humorous.

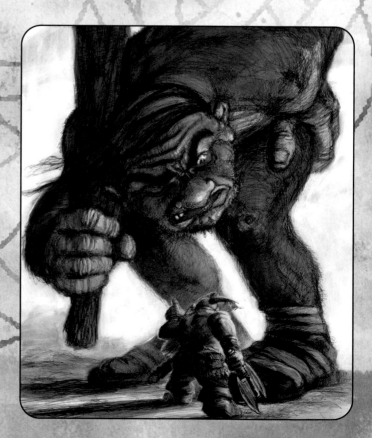

PULLING FACES

Size, proportion, posture, body language and lighting all contribute to providing your figure with life and animation; but nothing adds more so than facial expression.

Basic structure ▶

The human face can be represented by just a few lines and yet still be recognisable as a face. The essence of an expression can be boiled down to the shape of the eyes, eyebrows and mouth. As these examples will demonstrate, by subtly altering these simple lines, all kinds of emotions can be expressed in the most basic of drawings.

Anger, surprise, happiness, thoughtfulness can all be implied in half a dozen lines or so. Try it yourself. Sketch out as many different expressions as you can by using this shorthand technique. You may be surprised how the placement of a single eyebrow can alter the whole emotion of the face.

Many artists have a mirror to hand in their studio in order to reference more complex expressions by

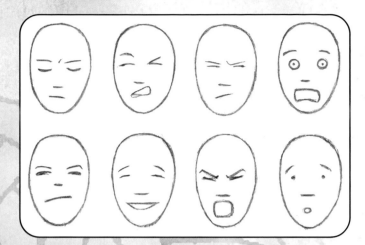

contorting and observing their own faces. It's a great shortcut, but just be careful that all your characters don't all end up looking like you!

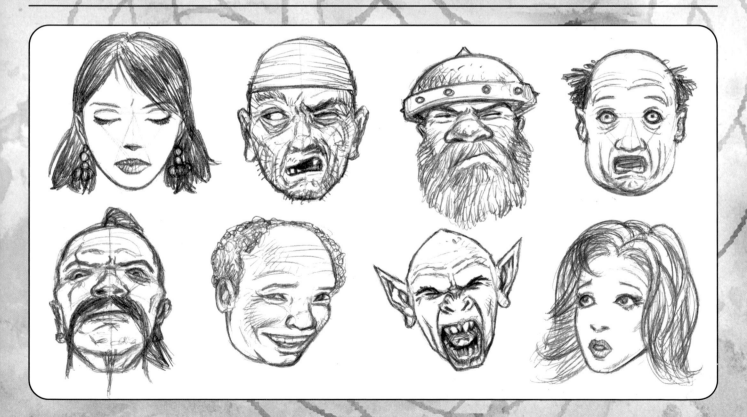

Expressions ▲

Here, the simple shorthand expressions have been applied to a number of fully-rendered faces, giving some idea of the range and variety available to you.

Additional details like a furrowed brow and wrinkling of the nose, crease lines under the eyes or around the

mouth can be added where they accentuate the expression rather than confuse it. Keep your character's expressions clear and uncluttered for the greatest impact.

It's easy to see how your character's facial expression can have a huge impact on your finished figure drawing.

THROWING SOME LIGHT ON THE SUBJECT

Lighting is another very important consideration of your illustration, whether you are drawing landscapes, objects or figures. Without light, you can't see anything. Light and shadow also create depth and form, which will have a huge impact on the drama of your pictures.

On an overcast and cloudy day, you may find there aren't many shadows around, as the sun's rays are diffused. But for a dramatic illustration, shadow is essential.

Shadows fall on the opposite side of an object, away from the light. It's easy to get carried away when rendering and shading and to start placing shadows where there ought not to be any, which can undermine the impact of your picture.

In fantasy illustration, you would usually expect the light to come from one source, but it's vital to get your illustration to look convincing. Always ask yourself: where is the light coming from?

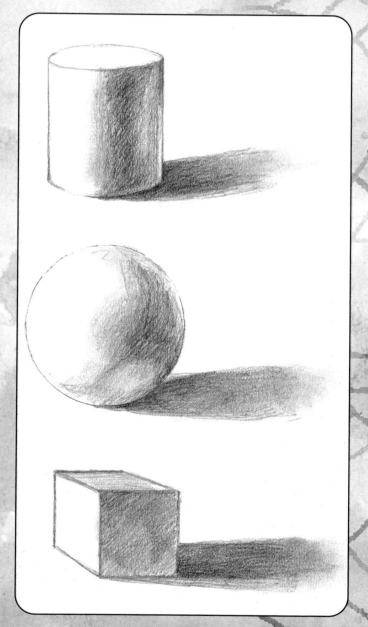

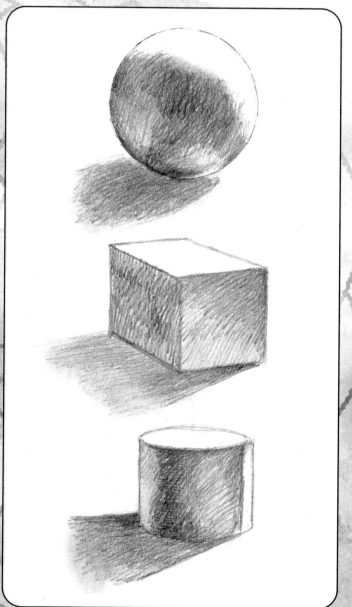

▲ Take these simple objects; a cylinder, a sphere and a cube. The light is coming from the left of the picture. Study how the shadows fall on the right side of the object and also the shadow it casts on the floor.

▲ Here, the objects are 'backlit'; that is, the light is coming from behind. It's also coming from the right and slightly above. Now, take this principle and apply it to the human head – or as in the next example, an elf's head.

Shadowing ▶

The first example here is lit from the left, slightly in front of the character's head. This creates a heavy shadow to the right side of the face. Note where the darkest shadows fall; for example, the ear and directly to the side the nose. Most of the face remains well lit.

Next, the direction of the light is coming from above. The light is bouncing off the character's hair, forehead, cheek and nose, in stark contrast to the eye sockets and the area under the nose. The asymmetrical shadow suggests that the light isn't quite directly above, but a little to our left.

The third example is lit from the right, slightly behind the model. This renders the face almost in complete shadow except for some dramatic highlights.

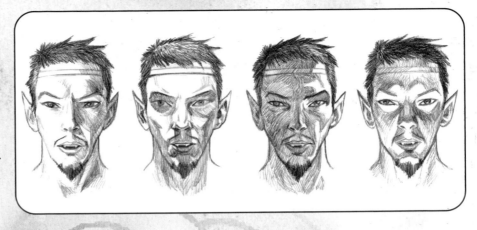

You can achieve a dramatic and unnatural effect by 'uplighting,' or lighting the head from below. In the final example above, the bottom of the elf's nose, his eye sockets and chin are all bathed in highlights. This creates sinister shadows on the forehead, cheeks and nose, adding depth to the character.

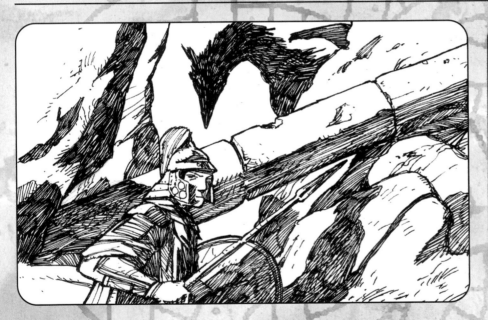

It's behind you ▲

The range of contrasts between light and shadow can add drama, impact and balance to any fantasy illustration.

In this composition of a warrior searching for a dragon amongst some ruins, the light is coming from the left of the picture, but also from in front of the soldier.

Note the heavy shadows on the underside of the rocks and also under the fallen column. This suggests that the light is also quite high up – possibly coming from a late afternoon sun.

The side of the warrior's helmet casts a shadow on his cheek, while the front of his body, turned away from the light, is in shade. His entire figure casts a long shadow to the right, falling over his round shield and the rocks beyond. You can also clearly see the shadow of his spear.

Meanwhile, the dragon itself lurks in the background, entirely engulfed in shadow cast from the large rocks on the left of the picture.

Using sculptures ▲

Drawing sculptures and models is a great way of learning how shadows fall. Use a lamp close to the object and move it around until you find lighting that you like. Make a drawing of it. Then move the light again and do another drawing. Analyze why the light can affect mood and drama and try to work this into future drawings.

This image of Doidalsas' sculpture of Aphrodite was sketched at the British Museum.

GETTING DRESSED UP

Now that you know how to create a dramatically lit, correctly proportioned figure in a provocative and emotional pose, you can dress him up. After all, you can't have everyone in your fantasy world running around naked. Your barbarian warrior may only require a loincloth, some boots and a big sword, but he will expect the princess that he is rescuing to be extravagantly garbed, complete with exotic jewellery and a fancy hairstyle.

It's important to try to understand how fabric hangs and moves, and how light falls on the folds in the cloth, otherwise you won't be able to create a realistic-looking flowing wizard's cloak.

You will find that drawing convincing clothing, and in general, drapery, is almost as big a challenge as drawing the human figure. Again, there are entire books devoted to the subject.

◄ Drapery

As always, start with a simple shape. A couple of gentle zig-zags or 'S' shapes will do the trick. Then add further lines, representing the depth of small folds and add shadow to the 'lowest' parts – the highest part of the fold of cloth will be white, or highlighted.

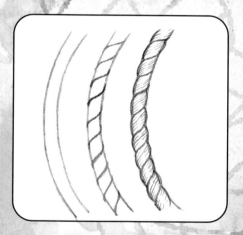

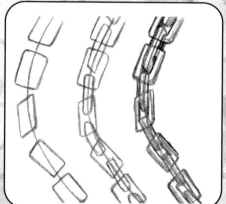

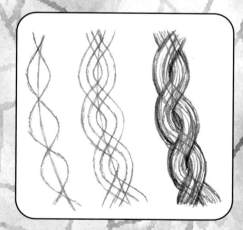

Ropes ▲

Ropes and chains can look a little tricky to draw, but they are constructed from very simple shapes. Draw two curved lines a short but equal distance apart. Then add diagonal lines in between the curves at regular intervals. These short lines can curve slightly right at the point where they meet the larger curves.

Chains ▲

Chunky chains start with a single curved line. Add similarly-sized rectangles along its length. Then add smaller, thinner rectangles (albeit the same length) overlapping the larger shapes, spanning the gaps in between. Try using this technique to draw chains with circular or oval links, and try to vary the shape of the chain as well.

Braids ▲

Building on a single line, draw two lines in an intertwining 'helix' shape where they cross over the central stroke. These two lines are the centre of each half of the braid, whose thickness is determined by the distance between the centre line and the widest part of the curve. Now you can build on each side of the lines to bring the braids to their full thickness.

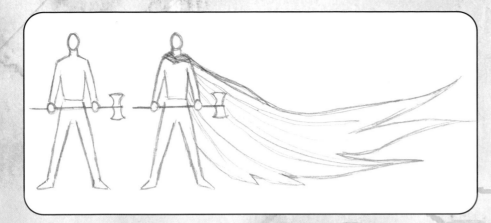

◄ Cloak

Without a billowing cloak, this figure would look much less imposing and dramatic. A few simple strokes take the picture to another level.

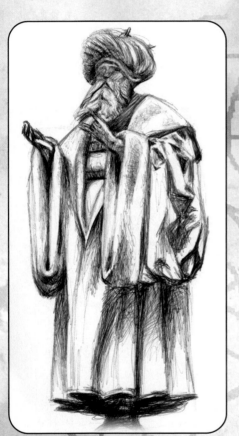

Folds ▲

This sketchbook illustration of a statue of Christian II of Denmark from the Victoria & Albert Museum in London is an ideal study in hanging drapery. His voluminous robe gives an impression of the size of the body beneath. The size of his sleeves alone is quite remarkable, as are the shadows that they create in their folds.

This statue was the inspiration for the main wizard archetype, which you will be shown how to draw later in this book.

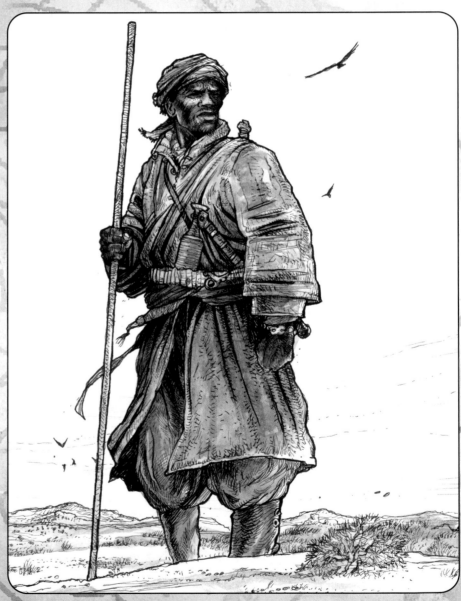

Appropriate dress ▲

This desert walker is wearing several layers of clothing and is adorned with a number of interesting items from the curved dagger tucked in his belt to the staff in his hand. This is a great example of how thought given to the design of a figure's garb adds interest and depth to the character.

Choosing media and technique

As outlined in the first chapter, there is a wealth of artists' media available to the budding fantasy artist. It's worth trying your hand at using as many different drawing and painting tools as you can, even when you have found a style or technique that suits you. Constantly trying new approaches will help you evolve and keep learning new tricks. It can be argued that it's better to be the master of one medium than a jack of all trades, but some experience of different techniques will certainly do you no harm.

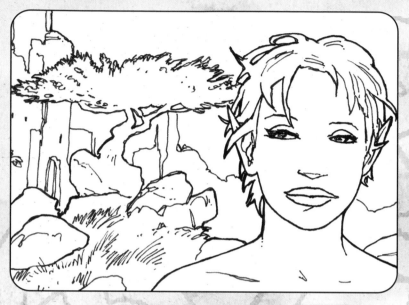

◄ Basic sketch

To demonstrate how each different technique can affect your artwork, the same single image will be used. This composition consists of a close-up portrait of a female elf, a tree and some rocks in the mid-distance and a mountain range in the background.

If you want to try to reproduce some of these techniques, you can create your own lightly outlined pencil image and photocopy it several times, or you can simply enlarge and photocopy this one. A simple outline can be as effective as a highly rendered image. But the fewer lines you use, the more important each line becomes. The very best artists would never draw an unnecessary line.

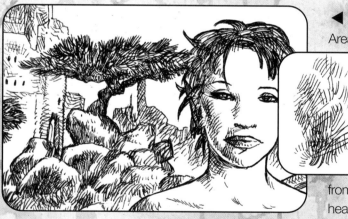

◄ Cross-hatching and feathering

Areas of tone representing shadow and form can be built up with your preferred inking tool by feathering; using short repeated strokes to approximately follow the contours of the object. These should be heavier in areas of dark shadow, gradating to lighter or less frequent marks in lighter areas. A waterproof fineliner pen has been used here. These are available with fibre tips or plastic tips and come in a number of different point sizes. These range from 0.1 mm for very fine detail right up to 0.8 mm and beyond for heavy outlines. Size 0.3 mm is excellent for general sketching.

◄ A sparse, light, organic stroke has been used in this example, giving a clean, fresh appearance to the image. Heavy outlines help to distinguish the foreground figure and mid-ground elements from the background, clearly defining the three 'planes' and adding depth to the picture.

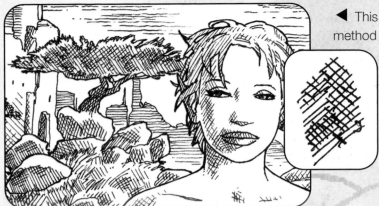

◄ This image demonstrates a very technical, uniform method of cross-hatching. Straight, parallel lines with a constant width are used for shading, combined with similar lines at forty-five degrees to create areas of darker tone.

There are literally limitless variations on methods of cross-hatching, and it's one of the ways in which you can develop your own style.

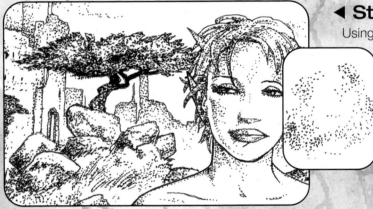

◄ Chiaroscuro

The use of high contrast between light and shadow in art is known as chiaroscuro. Large areas of entirely black shadow and brilliant white highlights create an extremely dramatic effect, although care must be taken not to let every element of the drawing disappear into darkness.

You may like to apply large areas of black by brush initially (called 'spotting') and then add smaller details with pen later, although vice-versa is also appropriate.

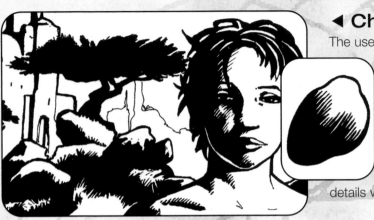

◄ Stippling

Using a rendering effect called stippling is for the very patient artist. Build areas of gradated tone by a using succession of dots - the closer together they are, the darker the tone appears. Extremely smooth gradations can be created by using this technique and a very distinctive end result can be achieved.

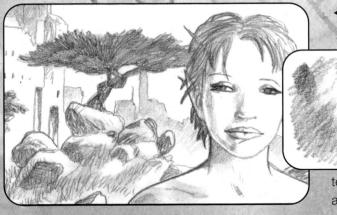

◄ Pencil half-toning

Pencil alone can be used to spectacular, almost photographic effect as it is excellent for creating subtly gradated tones. By adjusting your pressure on the paper, you can create a huge range of shades. Beware though, that softer grades of pencil can smudge easily, so care must be taken to keep your illustration 'clean.'

You can also use a finger to intentionally smudge areas creating a soft grey tone, but practise this technique before using it on a finished piece. Spray fixatives are available which will help to preserve your pencil drawings.

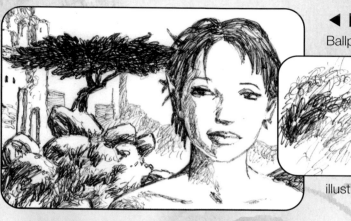

◄ Ballpoint scribbling

Ballpoint pens are not generally recommended as precision drawing tools. They have a habit of blobbing and running dry and it's very difficult to correct mistakes. They also tend to reproduce badly. However, good quality ballpoint pens do provide a surprisingly wide tonal range and they are often very good for sketching, scribbling and working up ideas. You can also use them to add details and boost outlines to illustrations in other media.

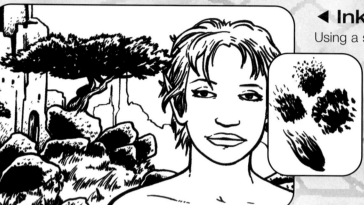

◄ Ink and brush

Using a sable brush and India ink can give you a much more fluid line than a pen, going from fine to thick within the same stroke. A wide variety of different textures are available to the experienced brush wielder. Brushwork does take longer to master than a pen, but once you have the knack, it is a very fast and expressive tool to use.

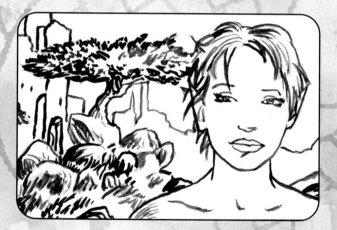

◄ Ink and wash

In this example of a dip-pen and monochrome wash, a sepia-toned ink has been used, although you can of course use a black ink to similar effect.

Draw the outlines with a split-nib dip-pen, although you could also use a fountain pen or calligraphic pen. You can apply textures to the tree, grass and hair, but avoid the indication of shading with the pen. That's because you will add form and shadow by using an ink wash in the next stage.

◄ Using a sable or synthetic brush, apply a wash – the same ink, watered down – over your pen outlines, to indicate shadow and tone. You can mix your ink with water in one or more small bottles, or you can charge your brush with ink and dip it into your jar of water to dilute it. This way you can create a wide variation of tones, giving your picture life and interest. Successive layers of wash will darken the shadows where required. Leave plenty of areas white otherwise your picture may end up muddy and flat.

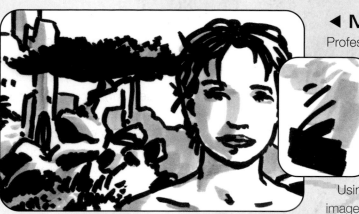

◀ Marker pen

Professional 'studio' markers are very expensive, but fortunately, a single marker can be used in a number of ways. Some even include two or three different size nibs in the same pen. Apply in successive layers to create tone and shadow. The lightest layers should be put down first, building shadow and form with further layers. Remember that these types of markers should only be used on special 'bleedproof' marker paper. Using markers for outline and shading gives a strong, bold image which is quick to render and creates impact.

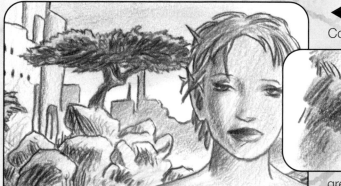

◀ Coloured pencil

Coloured pencils are best used for modest-sized illustrations or in conjunction with other media – it's excellent for boosting small areas of colour in coloured ink or watercolour illustrations for example. Draw the general outline of your image first. Areas of colour can be gradually built up, with successive lightly-applied layers of pencil creating subtle tones. Blue and yellow pencils have been used to create the green of the trees and grass, while the flesh tones include reds, browns, blues and oranges.

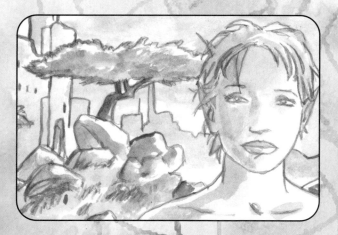

◀ Watercolour

Watercolours are translucent, meaning that after one colour is dry, another colour can be added, allowing the first colour to been seen through the second. Using a thin brush, draw in the outline of your picture in a neutral tone, for example a light grey or brown.

Build up areas of colour, starting with light tones – you can always strengthen the colours later. This will help you get the colour scheme right. Each successive layer will make the colour darker or more vivid, so it's best to err on the side of caution and leave plenty of white space.

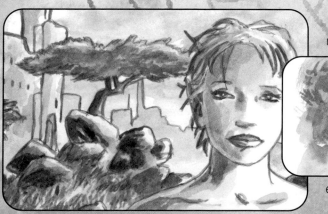

◀ Working quickly with broad, confident strokes will help make your image look full of life and energy. A small amount of opaque white gouache has been added to the bottom edge of the face to indicate reflected light and to add depth.

Applying colour wet allows all kinds of blending effects. Wetting the paper with clear water and dropping watercolours into it can create spectacular 'bleed' effects which are hard to control but effective nonetheless.

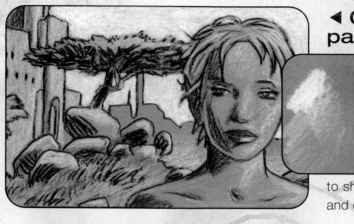

◄ Coloured pencil on coloured paper

This technique requires a slightly different approach as you will be working from a mid-grey base instead of white. A heavier and more precise application is required, creating an entirely different, almost painterly effect. You will need to add highlights to the hair, face, rocks and tree, rather than leaving them and allowing the paper to show through. Similar effects can be achieved using pastels and crayons when applied to coloured papers.

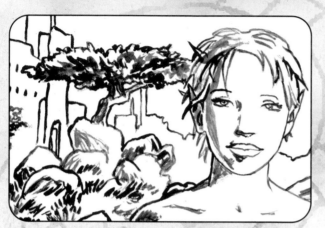

◄ Oils and Acrylics

These paints are the most difficult to master and many tutorial books are available on the subject if you decide to pursue an interest in painting.

Although oil paint and acrylics are based on different media (oil and water, respectively), they are applied and behave in similar ways. Acrylic paint dries much more quickly than oil paint, but is easier to use as it is water based. Oil paint must be thinned with linseed oil and is much stronger smelling. This drawing shows the preliminary stage of our acrylic painting.

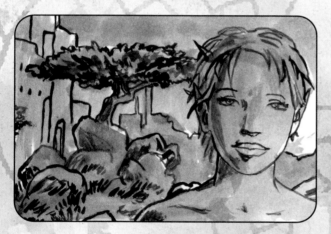

◄ As above, paint your outline in a dark colour. Unlike watercolour, the opaque acrylic will cover this, so your outline won't show through. You can also place areas of shadow, like the side of the face, to work out the tonal balance (light and shade) of the image. Start applying colour by laying a rough wash over the outlines. Here, lots of warm tones have been used. This will provide a mid-tone base for the final opaque layer to be applied.

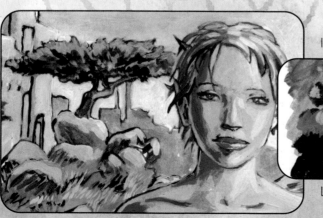

◄ Much like using coloured pencils on grey paper, you can add lighter or darker acrylic over the wash to add colour and form. Try not to use too much black when mixing your colours, although will find that you will add white to most.

All these colours have been mixed from just white, black, red, yellow and blue. For example, the flesh tone was created by mixing about one part yellow to three parts red with a tiny dash of blue to turn it from orange into a brownish skin tone. Lighten with white, and add more blue for the darker shadows.

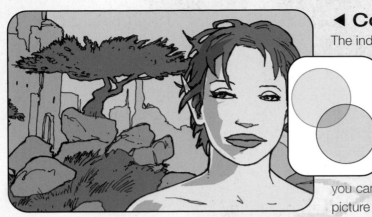

◀ Colouring on Computer

The industry standard for computer colouring is Adobe Photoshop, but it is expensive. There is a large assortment of alternative software available to the digital artist, ranging from high-end packages like Painter to freeware like Picasa.

Many computer-painting programs have features like 'paint bucket' to colour in flat areas in line drawings. Some programs use a system of layers so you can alter the colour, hue and brightness of one part of your picture without affecting others, as with the greys in this picture.

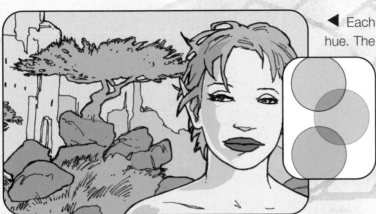

◀ Each layer of grey can easily be converted to an appropriate hue. The layers can also be set to appear transparent, so the line drawing underneath shows through. A single tone of grey transparently overlaying the face and hair adds shadow, creating shape.

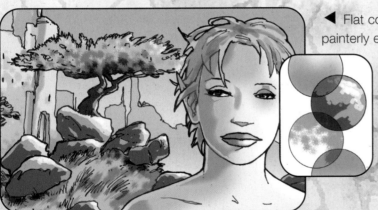

◀ Flat colours are effective, but you can also add more painterly effects with digital brushes in a number of textures. Different brushes have been used to add texture to the hair and the treetops. There are also methods of adding mechanical gradients, used here for the sky and mountains. Digital erasers have been applied to add highlights to the rocks and the face.

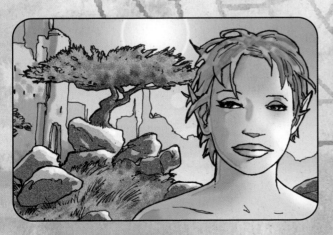

◀ More sophisticated programs also offer a wide range of special effects and 'filters' like lens flare, noise, blurring and chromatic effects to name a few.

Even when your digital painting is complete, it is easy to alter and experiment with new colour schemes without damaging your original. Beware, though, as the magical 'undo' button is a double-edged sword which can often delay your final decision-making process indefinitely.

Drawing fantasy figures
WIZARDS AND SORCERERS

The most obvious fantasy character archetype is probably the wizard, so it's a good idea to start with him. The following pages will show you how to create a completely adorned sorcerer, from a basic pencil drawing to a fully rendered image with ink and colour wash.

Rough sketch ▶

Gather your materials. An HB pencil and some paper is all you need to begin. If you want to colour it later, you'll need a thick paper or board as discussed in the first chapter, but to practise drawing just use some cheap office paper. You can always trace off onto board later, once you have an image that you like.

Remember to start with a centre line to give the character his spine, his body language. Start adding simple lines and shapes to your centre line to approximate the proportions of your character before you start to add any details. Use simple shapes to indicate the size and position of the head, upper torso and the pelvis. Hang lines off the shoulders for his arms, lines from his hips for his legs. In this instance, deliberately exaggerate the length of his limbs to give the figure a tall and graceful look.

The wizard's garments will be an important part of his character. Add a circle to suggest a turban, with a triangle for a typically pointy hat. Try sketching in some smooth, flowing curves to indicate a billowing cloak. Add a simple line to represent his magical staff and an inverted teardrop for a long beard.

His left arm is outstretched, his hand firmly grasping the staff, adding an element of strength and authority to the figure. His right arm is relaxed, indicating self control and calmness.

Don't worry if you have to keep redrawing the lines until you feel happy that they're in the right place. Start sketching very lightly at first, making the lines darker as you firm up the structure. There's no need to keep erasing.

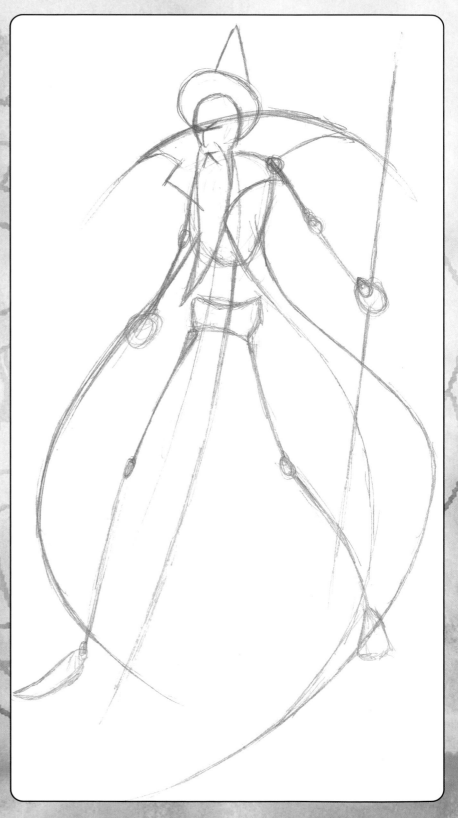

Figure ▶

When you're happy with the rough overall shape and balance of your outline figure, you can add some volume to your character, dressing his arms in sleeves with flamboyant ruffs, adding facial features, fingers, and more folds to his robes.

The wizard's right hand is hidden behind the cloak, but it's important that you're aware of its position to ensure that the ruff is placed correctly.

Notice how the line of the top of the collar passes almost right through the line of the eyes, drawing the viewer's attention to the face of the wizard. Both sides of his robes sweep up, again directing attention to the head.

By tweaking a kink into the top of the hat, you increase the visual interest in the figure. Make the top of the staff a bold, dynamic shape, like a twisted, gnarled animal antler.

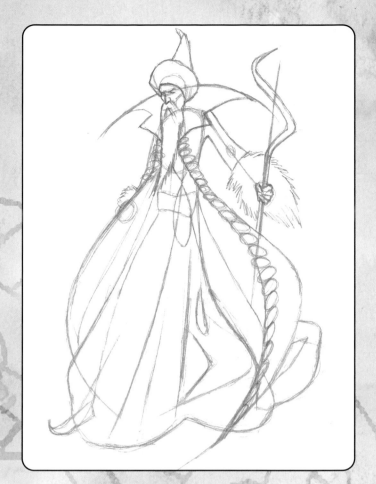

Definition ▶

You're now able to add some surface detail and refine the main shape outlines, which will make them more dynamic and graphic.

Remember, you're preparing the drawing for the inking stage, so there's no need to overdo the detail, but just include enough information to give you confidence to know where to place those ink lines.

Drawing a repeated pattern on the wizard's jacket gives the impression of a luxurious embroidered garment, even though only a small edge is visible.

Although his robes account for much of the total surface area, you should concentrate on small areas of detail like the face and hands, as these will the main focus of the viewer's attention.

Note the end of a slippered foot peeking out from under the wizard's robes, so that it doesn't appear like the figure is simply floating in space. Allowing the cloak to gather and lie on the floor also helps to 'ground' the figure.

Other small details that you want to include in your final image should be indicated, like the electrical 'crackle' of his staff, the folds of his turban, the expression on his face and his assorted jewellery.

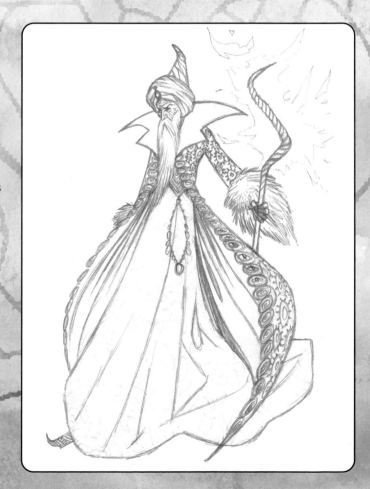

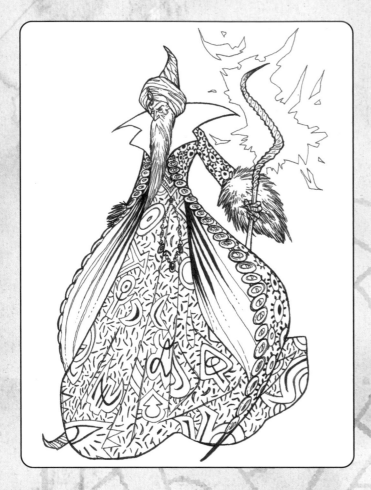

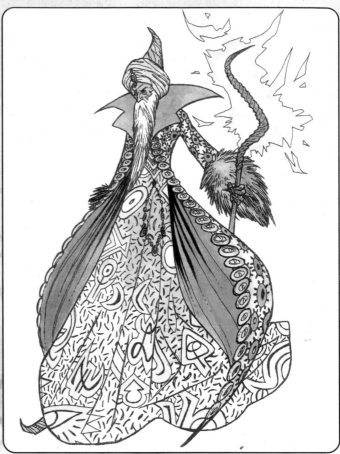

Inking ▲

With all of the pencil 'construction lines' in place, you come to the inking stage. Ink is more difficult to correct than pencil, so take a deep breath, relax, and start inking over the top of your pencil lines.

Try to create a smooth, sweeping line for the cloak and robes. If you are using a brush or a pen with a split nib, you can vary your line as you feel appropriate. A waterproof 'fineliner' pen has been used to create this example.

The outline of the character here has been given a thicker, heavier line to help him 'pop' off the page. Note the heavy shadow underneath the wizard's jacket. Areas of high contrast like these help to give the illustration depth.

You may wish to add further detail, like arcane mystic symbols, or 'sigils', to the wizard's robes. Even if you've already begun inking, go back and work out what you are going to do in pencil first. You can retouch inking errors with 'white out', but this may cause problems if you are adding colour on top.

Basic colours ▲

You can now start to apply some colour. You will need to use a transparent medium like a wash in watercolour paint, or coloured inks (as above).

In this example, only three colours have been used – cyan, magenta and yellow.

You can thin coloured inks with water for lighter tones, and dilute black to create darker tones for shadows. Brighten or darken colours by adding further layers of wash.

A limited palette can give a more coherent colour scheme. Here, reds and oranges are used dominantly, by mixing yellow and magenta in differing proportions.

Coloured inks aren't available in a huge range of colours, but they are relatively easy to mix. You can either mix the inks in a receptacle, or apply the ink on the paper in layers to create the required tone.

Finished image ▶

You can see in the final image how additional layers of ink make the colours more vibrant. You can also add coloured pencil for additional effects. Orange pencil applied to give the wizard's staff add some extra 'fire', and some blue pencil added to the sigils on his robe give some colour contrast. Study how the lighting effects describe the shape of the jewel in the wizard's turban.

Finally, you can add some white highlights with white gouache, acrylic or 'white out' or any kind of opaque white paint, but not correction fluid as this may react with the black ink or marker. Adding small white spots of paint to areas like his jewellery, turban and eyes add life and depth to your illustration. Remember to think about the direction the light is coming from in your illustration and don't overdo it.

Don't worry if your illustration doesn't turn out exactly like this. In fact, ideally your own personality should show through in your drawings which will hopefully lead to your own distinctive style. But try to spot the weaknesses in your drawing and concentrate on improving those next time.

Colour tests

You may want to test your colour scheme before applying ink directly to your artwork. You can do this by creating a 'colour test' – a quick colour sketch using colour pencils on a separate piece of paper. You can rough out your image by hand and colour it, or for an important piece, you can produce a number of photocopies and colour those in a variety of schemes to see which is most appropriate.

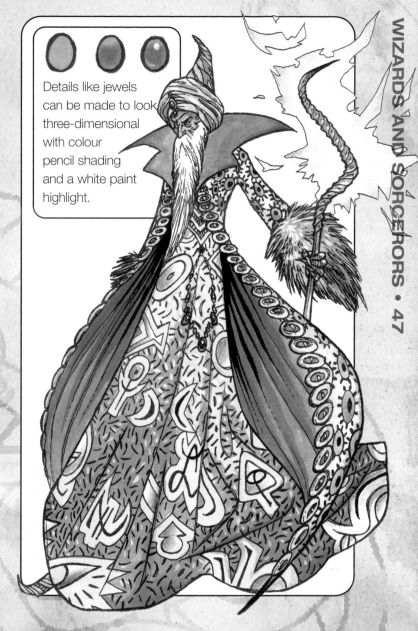

Details like jewels can be made to look three-dimensional with colour pencil shading and a white paint highlight.

◀ Grindley the Grey

Here's an altogether friendlier, and perhaps more stereotypical wizard. Notice how the pipe and feather draw the viewer to his face. His extraordinary nose almost mirrors the shape of his hat. His patched-up headgear and his benevolent smile lead you to suspect that he is a much more likeable character.

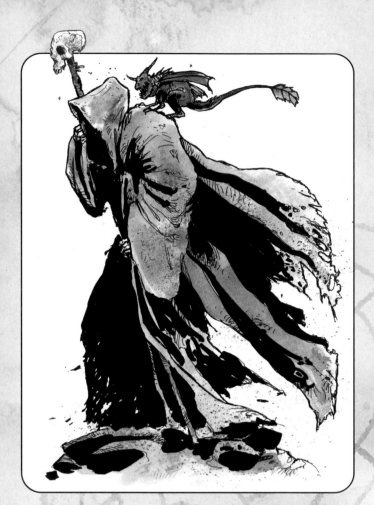

◀ The black magician

There are evil wizards as well as good wizards. Here's a character that looks like he's just a bag of bones.

To draw the Black Magician you might need to concentrate more on your drapery than your anatomy, but always start with the stick figure to get your proportions looking right. You might suspect from his hands that he's little more than a stick figure anyway, under his hooded cloak. His pose suggests the character is bent or deformed in some way or in pain.

He's standing on some rocks which suggest the top of a mountain, and judging by the movement of his cloak in the wind, it's a breezy day.

This example was drawn with a waterproof fineliner and a watercolour wash, applied 'wet' so that the colours bled into each other, creating interesting effects. A fat marker pen was used for the large areas of black, giving the image dramatic shadow and depth. An old paintbrush was used for the 'spatter' effects and brown and red coloured pencils were used to add vibrancy to the staff and the figure of the imp.

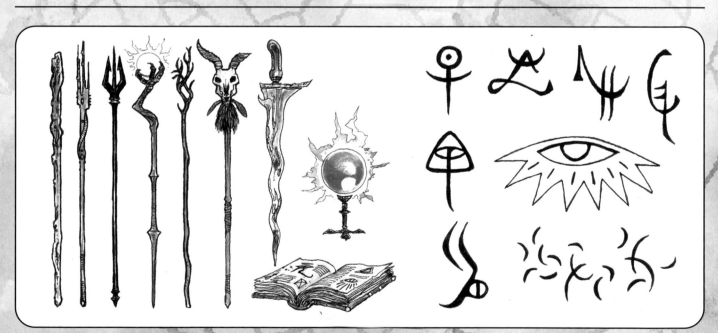

The wizard's accoutrements ▲

The wizard, mage, magician, sorcerer, magus, call him what you will has all manner of accoutrements at his disposal. The most obvious of which are his staff, or magic wand. Here there are designs based on forks, bird's claws, tree branches and one decorated with an animal skull and feathers.

The wizard's garments are covered with designs based on magic symbols, or 'sigils.' Here are a few that you can work into your own character designs.

No wizard would be without his book of spells or his magical orb. Study the shading and lighting effects to see how the impression of a sphere has been created. You could also add rings, wands and magic potions.

◄ The sorceress

This sultry beauty is very relaxed, reclining lazily on her elegant throne, draped with animal skins, dressed in an exotic Eastern style outfit and complete with her giant pet lizard draped around her shoulders.

Look at how the addition of the lizard adds to the compositional design of the illustration, its tail curling around and enclosing the upper part of the sorceress's body, leading the viewer's eye to her face.

Notice how the bangles on her arm fall at different positions and the rows of pearls drape down her arms. Study how the light is coming from behind the sorceress, from somewhere over her left shoulder. Her face is cast in shadow and the light pools on her chest, stomach and thighs.

This character was inspired by a rough life drawing and worked up into a detailed sketch. If your drawing becomes too messy and complicated, you can always trace it out onto a fresh sheet using a lightbox. In this example, the finished sketch was traced out onto marker paper – a special type of paper designed not to bleed when markers are applied.

The line work was rendered with a fineliner pen and the grey shadows were added by building layers of tone using a grey marker. You can buy professional markers in a huge range of different grey tones, but they are very expensive, so creating darker tones by adding successive layers is a cheaper alternative. Highlights were added with a white, water-based paint.

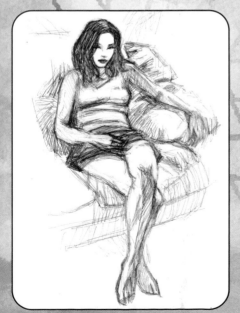

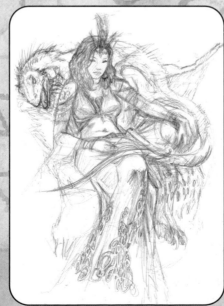

WARRIORS AND BARBARIANS

Your fantasy world will need a hero. Your hero may be a wizard, or a princess, but it's more likely you will want to draw a swashbuckling, all-action fighting hero like the young man on the next few pages.

The warrior swordsman ▶

Start with a warrior swordsman in a dynamic pose: feet wide apart, sword in hand, alert and ready for action.

As always, begin by sketching out the simplified skeleton, or armature. Note the curved 'action line' which incorporates the neck and spine, indicating that the warrior is leaning forward slightly, alert and ready to pounce. Here, the shapes that signify the skull, ribs and pelvis are a little more than just simple ovals. The shapes look more like the underlying skeletal elements that they are representing. With a little practice, you will soon be doing the same.

Notice the angle of the sword, held in front of the body, pointing slightly upwards. This strengthens the balance and composition of the whole image.

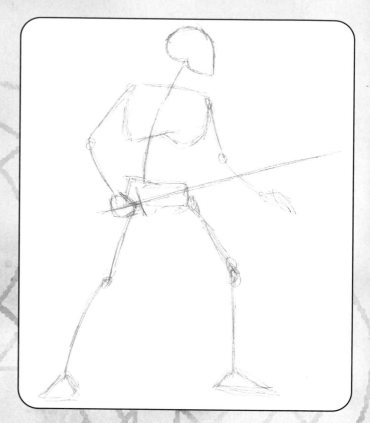

Basic shapes ▶

As you have learned by now, you can build up the figure using simple cylinder shapes. You will probably find that trying to get the shapes of the hands and the feet looking right is the hardest. If in doubt, look at your own hands and feet. Grab a ruler and stand in front of a mirror if you can't work out how he should be grasping his sword. It's better to figure out all the complicated, dull stuff at this stage rather than trying to fix it later.

You can also place your construction lines for the facial features at this point.

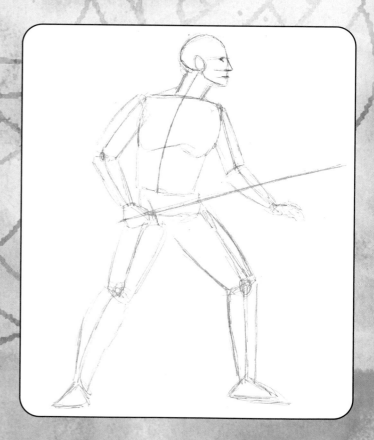

Clothing ▶

You can now dress your warrior. You may wish to base his clothing on some reference you may have found from a book, magazine or film. This warrior's garments are based on medieval garments, made from quilted leather.

It's a bulky outfit, with wide sleeves, flared jerkin, gauntlets and heavy flapped boots, all of which should fit loosely on the body. Note the way the warrior's large shirt and trousers fold around the elbows and knees.

The angular lines are graphically very pleasing – or, to put it another way, the shapes of the clothes look good on the page.

Heavy clothing like this can make the limbs appear stunted. Even though it may be technically correct, you may find that you will need to tweak certain elements in order to make your figure look 'right'.

Here you will want to add the remaining elements of your design like the sword detail, construction lines for a pattern on his jerkin, hair and facial features. The placement of the scabbard is drawn in even though most of it will be hidden by the torso. Look at the way the angle of the scabbard's shoulder strap and its knives complement the angle of the sword, making neat yet dynamic shapes in the centre of the image.

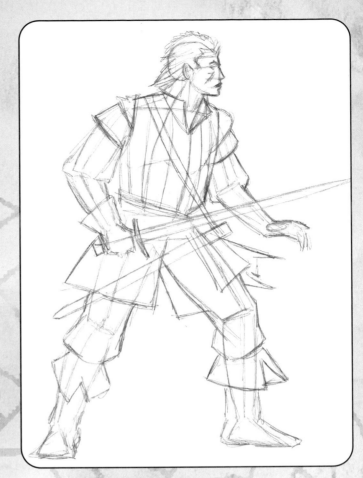

Fine-tuning ▶

Before starting to tighten and fine-tune your final design, you may wish to either erase your construction lines or trace out the figure using a lightbox. This will help keep your final image clear and uncluttered.

Final details like the folds and creases of the clothing and indications of shadow can be added here. A grid has been indicated on the warrior's jerkin as a guide on which to lay a simple pattern. Note the way the gridlines follow the contours of his upper torso, adding shape and solidity.

This example is going to be painted with a wash directly over the pencil drawing, so it's not necessary to put in every tiny detail, as these may be lost when you paint over. But it's important that the overall shape and proportion of your drawing is correct, as you won't be able to change anything major once you start adding colour.

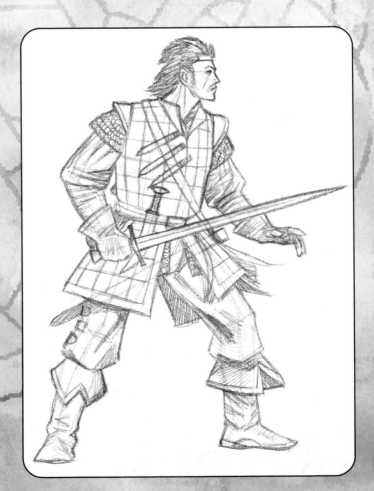

Applying colour ▶

In this example, colour will be applied using a watercolour wash, although you can use coloured inks or acrylic wash to similar effect. Using a fairly limited palette initially makes it easier to maintain colour balance. This stage basically uses a brown, red and light blue.

Remember not to cover every little area with flat colour, as this will deaden the image. Leaving small highlights of white adds life and sparkle to your drawing.

Here, a simple blue wash behind the warrior's legs adds colour contrast and 'grounds' the figure in the picture, adding a sense of distance and three-dimensionality.

A 'spatter' effect can be added to suggest smoke or dust by dipping an old toothbrush in the paint and gently flipping the bristles with your finger.

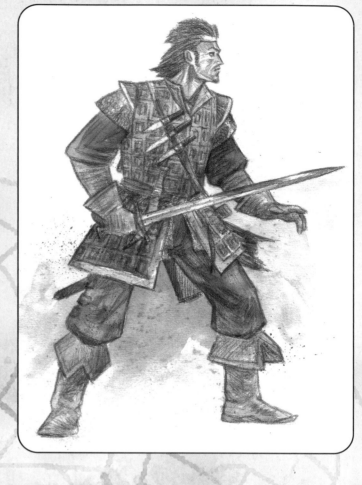

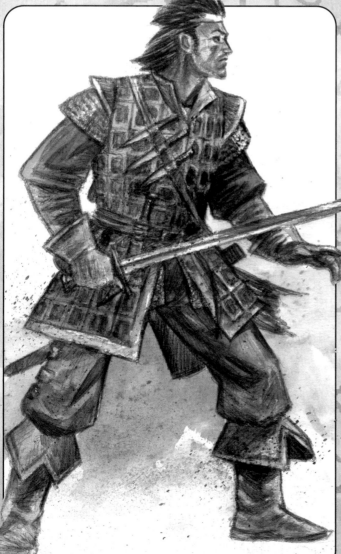

◀ Shadowing

Adding further layers of wash adds shadow or brightness, depending on the colours and density of the paint you use. It's much easier to add shadow and to darken colours than it is to lighten or brighten them, so always try to err on the side of lightness.

The darkest shadows appear under the warrior's arms, under his jerkin at the top of his legs and under the flaps of his boots; places where the object casting the shadow is nearest to where the shadow is being cast.

Coloured pencils can be used to boost the edges of the figure, to add final touches and to deepen the shadows still further.

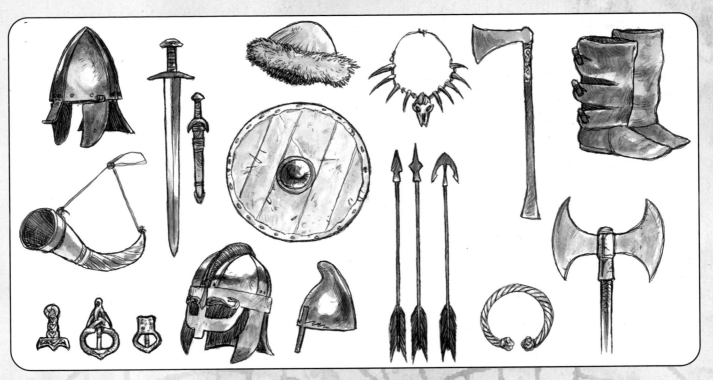

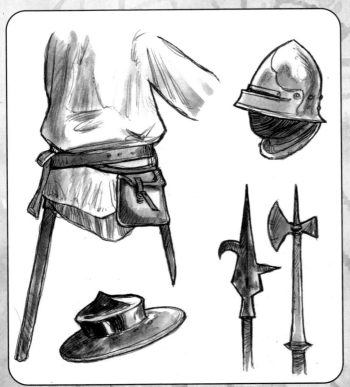

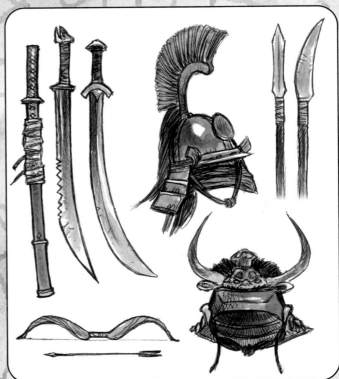

The warrior's armoury

No warrior is complete without his weaponry. Here's a selection of swords, staffs, axes and arrows to give you some ideas, along with some sample helmets, hats, shields, buckles and other adornments that your fantasy warrior shouldn't leave home without.

When accessorising your figures, you should bear in mind what sort of time period they live in and what area of the world they are from. There are many different kinds of warriors that you can use as sources of inspiration, from bronze-age barbarians to Japanese 13th-century samurai warriors, to Saxons and Vikings from the Dark Ages, to medieval 15th-century soldiers.

You might like to invent your own kind of warrior by mixing up two or more warrior types; perhaps a time-travelling mercenary, or a globe-trotting medieval sword-for-hire. But he will be all the more convincing if you think about his background before designing his costume.

The barbarian

Here's an entirely different sort of warrior – an original barbarian of the Robert E. Howard variety.

This guy's all muscle, with a thick torso, heavy arms and legs. He has a wide jaw and nose to match and his hair is long as he's too busy to get to the barbers. His stance should indicate strength, even when relaxed. Note how his legs are fairly wide apart, with most of his weight on his left foot. He's grasping his twin-bladed staff firmly. You wouldn't want to argue with this guy.

There's not too much to worry about in the way of clothing, as barbarian warriors are so tough (or so stupid) that they don't need garments to protect them.

His loincloth, boots and wristlets are made from animal skin and note how the necklace of animal teeth makes the outfit appear more complete.

Compare the pencil layout stage with the finished illustration. Try drawing him yourself, starting with just a stick figure. Notice how thick and heavy his limbs are. This example was rendered in pencil and watercolours.

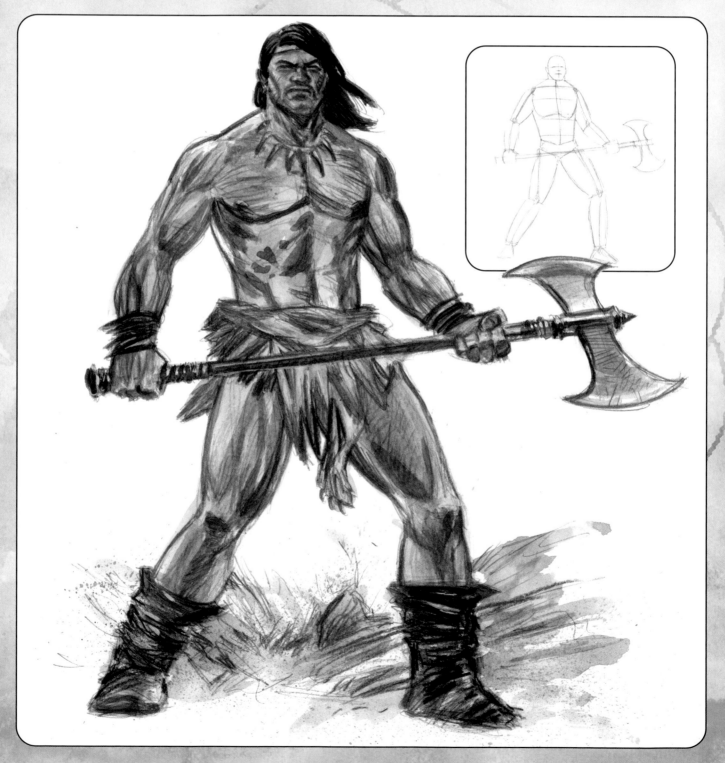

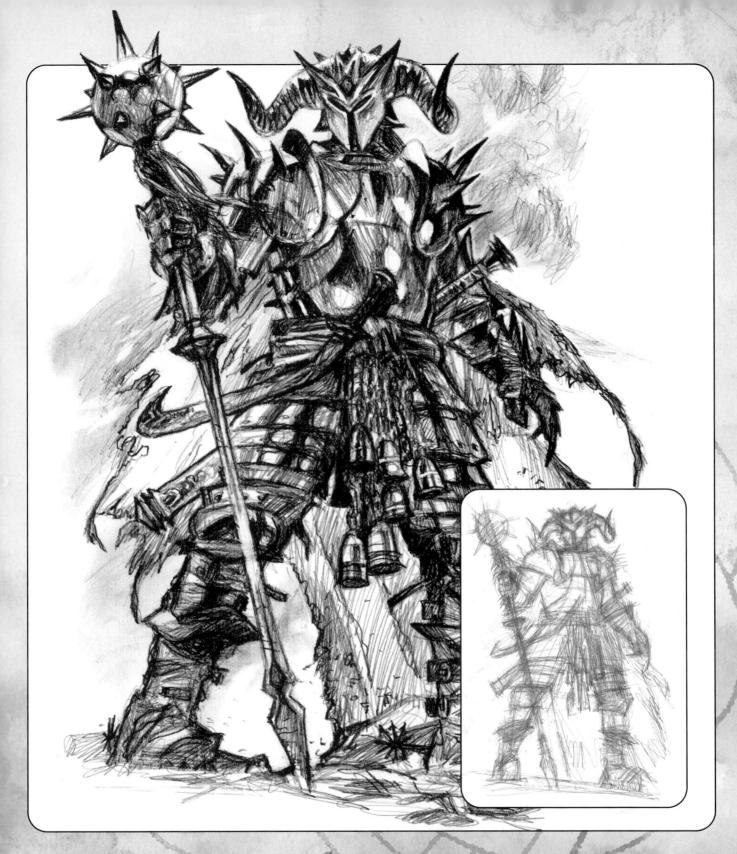

The evil knight

Sometimes a warrior going into battle likes to protect himself with lots of armour. This fearsome-looking chap is wearing layers and layers of protection, spiky shoulder pads, assorted sheathed swords and is holding a nasty-looking mace.

His elaborate helmet consists of a many-pointed face plate with three small slits for his eyes and nose and impressive buffalo horns.

What makes this knight look so evil? His pose signifies strength and confidence, but the fact that you can't see his face suggests secrecy.

This illustration has been rendered entirely in shaded pencil tones. To use this technique, you need to start with a fairly clean outline, so it's probably best for your underdrawing to be retraced on a separate sheet before attempting the final rendering.

MAIDENS AND PRINCESSES

Now it's time to attempt to draw a female fantasy character: a beautiful and charming young princess.

Initial sketch ▶

Start by sketching out your stick figure. The centre line should be drawn first to give the character her pose, representing her spine. Draw in the oval shape for her head and you can use the length of her head to measure out her body length if desired. To emphasise her nobility, make her about eight-and-a-half heads high, with much of the additional body length being added by her extra-long legs.

Add onto the spine a boxy oval to represent her rib cage, an oval for her hips, simple lines for arms and legs, not forgetting placement of her elbows and knees. Rough squares and triangles are enough to indicate the size and position of her hands and feet. You can also indicate the positions of her eyes, nose and mouth at this stage.

This example is a fairly static pose, but note that the weight of the princess' body is on her left leg. To balance herself, her spine is gently curved and her right leg is stretched out, hand on hip. Her left hand is grasping a sword, simply indicated by a straight line, to add some visual interest.

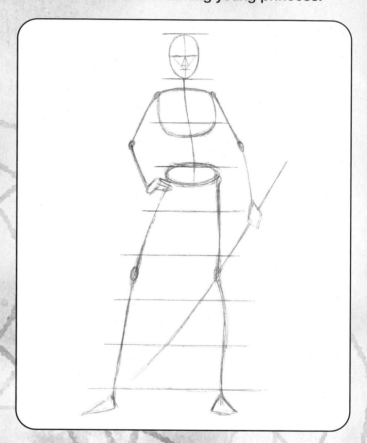

Clothing ▶

Now it's time to flesh out the armature and dress her up. She's wearing an elegant dress with large bustled skirt to underline the fact that she's a princess. After all your hard work in getting her legs to look right, you're going to cover them up. This might seem like it was a waste of time, but the position of her legs define her pose and gives the character the right balance as well as the correct height.

Flesh out her arms and draw in her neck. Her ribcage dictates the shape of her waist and helps to position her breasts. This type of bodice creates her cleavage.

Draw her hair as a single shape, flowing down to her shoulders. Her dress has elegant cutaway sleeves which give the figure stability and shape. Anatomical detail like facial features and fingers should be worked out lightly at this stage.

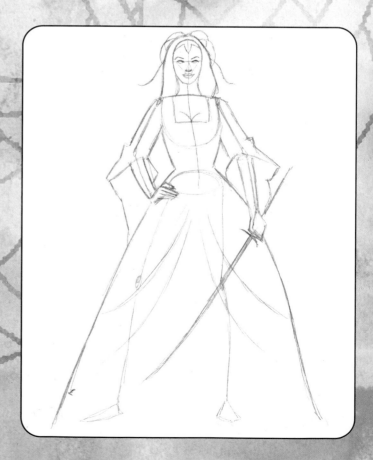

Definition ▶

After lightly erasing your construction lines, you can really get to work on the final decision-making, strengthening and smoothing the definitive lines, as well as adding in fine detail. An elaborate tiara can be added, folds and creases in the fabric of her dress should be indicated. Draw in a lace front to her bodice, suggesting the tightness of the garment and add further detail to her clothing. If you're stuck for ideas, you should look for inspiration from historical books and movies. With a few tweaks here and there, an 18th-century French lady's finest garments can become the costume of a 23rd-century fantasy princess.

Make her eyes and mouth into strong, graphic shapes. When you draw faces (and anything else for that matter) from a distance, you shouldn't worry about putting in every little detail. In fact, this can make your drawing look cluttered and amateurish. Look closely here and you will see that her eyes, eyebrows, nostrils and lips are very simple, iconic shapes.

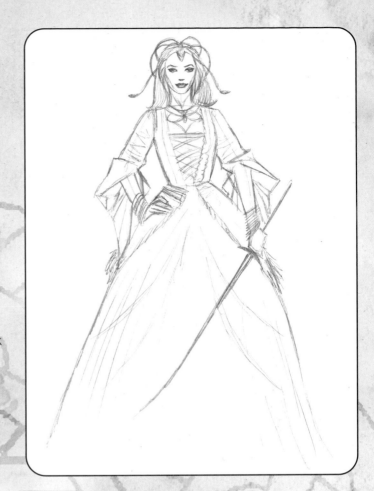

Final rendering ▶

With the basic framework in place, you can go to town on the final rendering. The elegance and opulence of the princess can be shown by the richness of detail in her dress, sword and jewellery. Careful gradated tones of soft pencil can be used to shape and pattern her bustled skirt and add shine to her dark hair.

The simple, overhead lighting scheme (indicated by the shadow under her chin) is effective and suggests that the princess is standing under a spotlight. Delicate shading and lightness of detail implies a translucent mesh fabric on the arms and lower parts of the skirt.

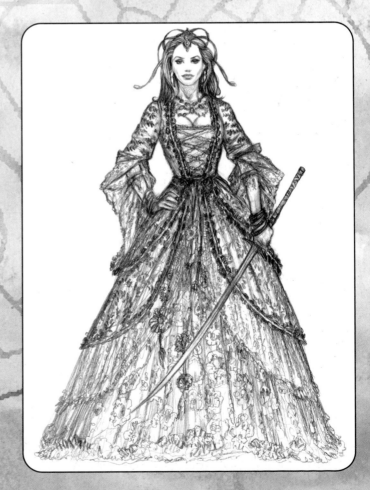

Jewellery ▶

Not every little pattern and design on clothing or jewellery needs to be – or indeed, should be – drawn in great detail. Simple scribbles and shading can give the impression of intricate design, without being intricate in itself. Here are some examples used on the previous page that you can practise copying and applying to your own designs.

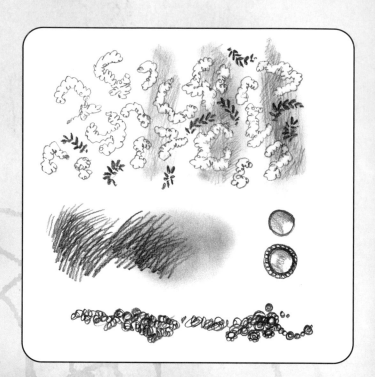

Pretty in pink ▶

Here's another variation on the princess theme, this time a more magical-looking, sexier character. Again, her spine is slightly curved, with all of her weight on her left leg (furthest back). This time, it's easy to see why you need to draw in all her limbs – otherwise it would be very difficult to place her feet in the right position. Her posture is relaxed, elegant and her gaze is intense. Her silk dress clings to her body, making the accuracy of her underlying body shape very important. Note the careful placement of the folds of her dress.

Outline the figure in ink – a dip-pen has been used here, in a quick, slightly 'scratchy' style, building up heavier outlines with multiple lines.

Apply a colour wash in fast, simple strokes, using multiple layers to create gradated shadow and form. The rough and ready application adds life and energy to the illustration. Of course, it's important to add the shadows in the right places, otherwise the figure will lose its form.

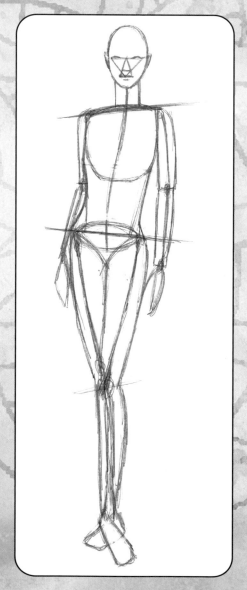

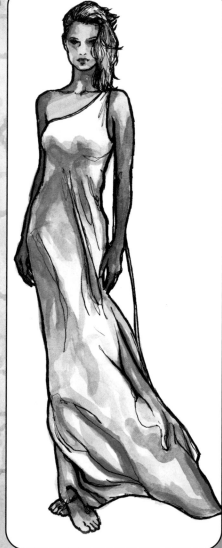

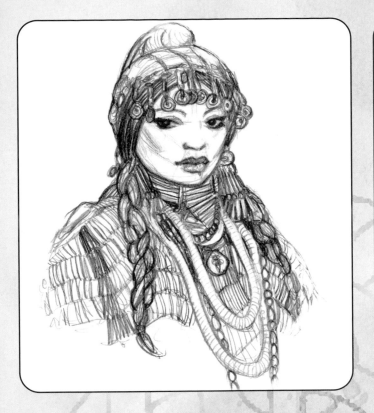

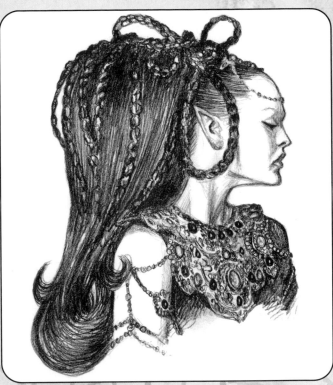

The barbarian princess ▲

This exotic barbarian princess is fully adorned with braided hair, headdress, beaded jacket and assorted jewellery. It all looks very complicated, but thought out logically and added carefully in layers, it's not as daunting as it may first appear. Notice how the tiny shells hang from her headpiece, and how her thick necklaces follow the contour of her body.

The elven princess ▲

This beautiful pencil drawing of an elven princess (you can tell she's an elf by the ears) is an excellent example of how hair and jewellery can enhance a fantasy character. Again, look closely at how the jewellery adorning her exotic breastplate is implied rather than explicitly drawn. Her rather extreme hairdo is given its shine by the white highlights offset against the black.

◄ The princess's wardrobe

Here's a further selection of objects that you can add to your princess costumery and, with a little reference work you can find an endless variety of items that you can adapt and modify to suit your character's requirements.

On display here are some headdresses from the Far East and medieval times, a tiara and even a cavalier-style feather hat. Items like fans, daggers and magic lamps are always appropriate, and perhaps your noblewoman likes to train small prehistoric flying creatures.

FAIRIES, ELVES AND FOREST FOLK

The fairy is very much a fantasy figure, even though some insist that they do actually exist. The fairy is a sylph-like figure: slim, delicate and elegant. Despite their tiny size, their proportions are very similar to a human's, with perhaps slightly elongated limbs. The most obvious difference is their pointed ears.

The fairy ▶

Start, as always, with the stick-figure. You'll find that this fairy is in a more ambitious pose, viewed from the side, spine arched, leaning forwards with her legs climbing, ready to take off at any moment. Her head is turned slightly towards the viewer.

Next, start to flesh out the bulk of the figure. Her limbs and body will be very slender, giving the impression that she is as light as a feather. Remember to sketch lightly at first, 'searching' for the right line. Your first attempts are certain to look far messier than our example here, but don't worry, as with practice you will start to use fewer lines and your art will start to look 'cleaner.'

The fairy's head is just about at a three-quarter view, and you should be able to place the lines for her features accurately using the rules you have learned from the earlier chapter. Note the left arm covering the knee – you should always draw even the 'hidden' limbs to ensure that everything appears in the right place.

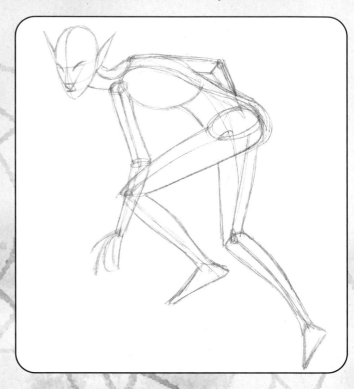

◀ Reference

This coloured pencil study of a dragonfly is perfect reference material for the fairy's wings. Study the drawing and consider the construction, shape, texture and patterning of the wings. Think about how you could apply this to your drawing.

Details ▶

Start refining the basic shapes into feminine, lithe-looking limbs with gentle strokes of your pencil. Add in facial features – almond-shaped eyes, pointed ears and sleek hair sweeping back. Sketch in her wings, using the knowledge that you gained from studying the dragonfly. Draw on her close-fitting clothes – which, being a fairy means they tend to be rather torn and frayed at the edges.

Note how the flowing parts of her dress and her wings reinforce the impression of a 'V' shape pointing in the direction she's about to travel, leading the eye to her face.

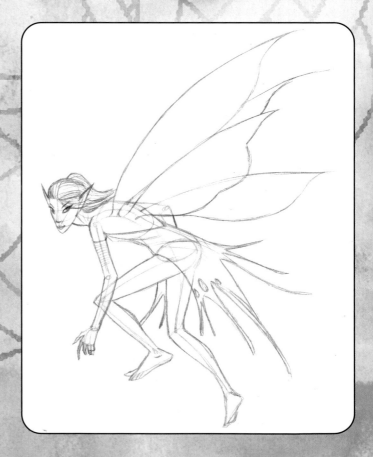

Colouring ▶

Before you start to colour your drawing, you will need to erase your unwanted lines, or trace out onto a new sheet so that your final illustration doesn't look too messy.

Render the final outline using a soft leaded pencil or dark colour pencil, as this will give you a softer, more feminine outline.

Using a watercolour wash, paint in areas with flat, light colours at first, to check that you are happy with your colour scheme. A background of green has been applied here to suggest the colour of vegetation – after all, fairies are usually found at the bottom of your garden. The first application of watercolour can be applied very quickly, without too much concern about covering every tiny area with paint.

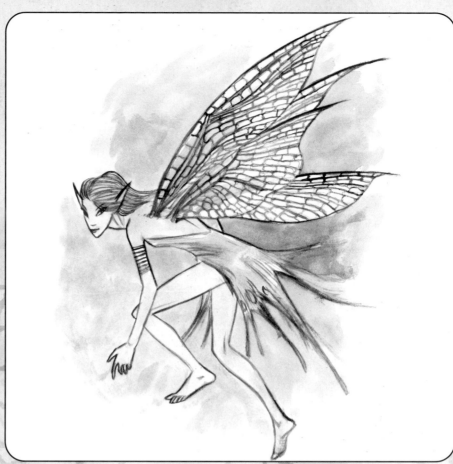

Layering ▶

Subsequent layers of watercolour can be applied a little more carefully, supplementing stronger colours and shadows where appropriate. Try to leave some white highlights on the back of the fairy's legs and arms to help to define her shape and distinguish her from the background. A dirty green wash can be added to parts of the wings, which should make them appear translucent. Final small details can be added with colour pencils.

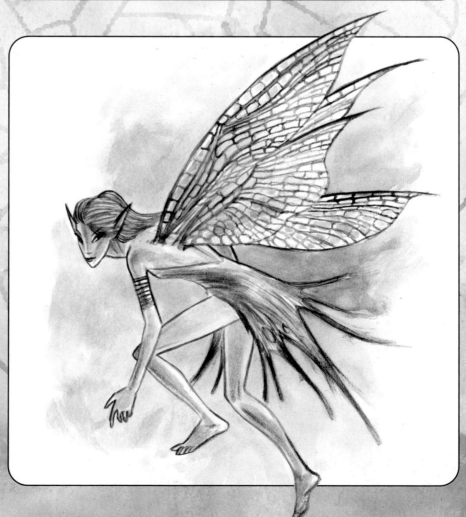

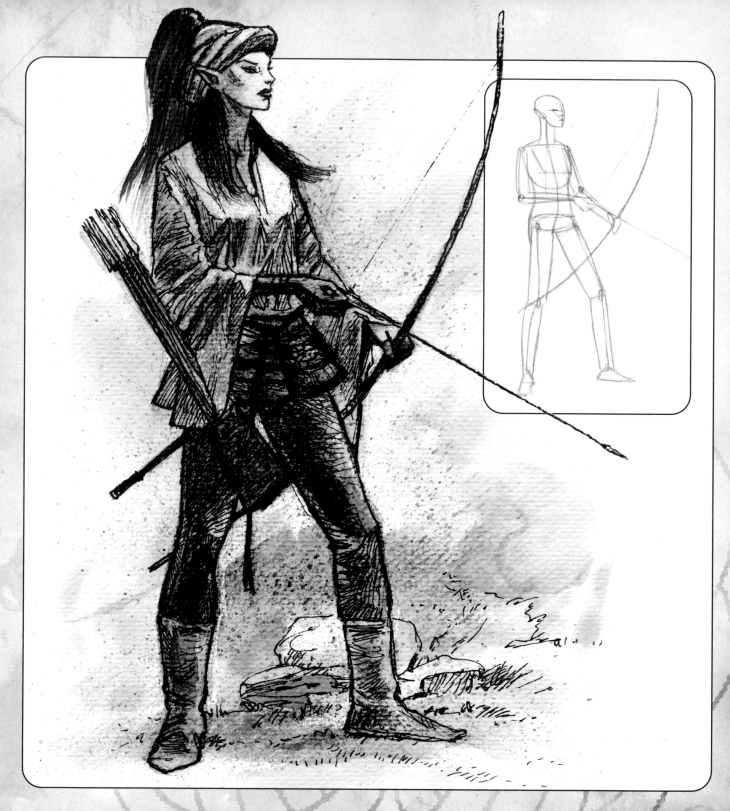

Elf-maiden archer

Elves generally appear to be similar in size and physique to a human, but with some subtle, but important differences. Their body shape and features are more slender and elegant, their complexion is very pale, their ears are severely pointed and their posture is always extremely graceful.

This female elf archer is a typical example. The willowy bow and long, slim arrows mirror the elf's own anatomy. Note her relaxed and yet alert pose. The curve of her bow and angled arrow frame lead the viewer's eye to her face and chest, which are bathed in white light that emanates in front of and above the figure.

The light outline of some rocks, a little background colour and the suggestion of a shadow help to give depth and solidity to the picture.

Also note the texture of the paper used for this illustration, which adds a certain painterly quality to the image. This effect was achieved by using watercolours on a canvas-textured watercolour paper.

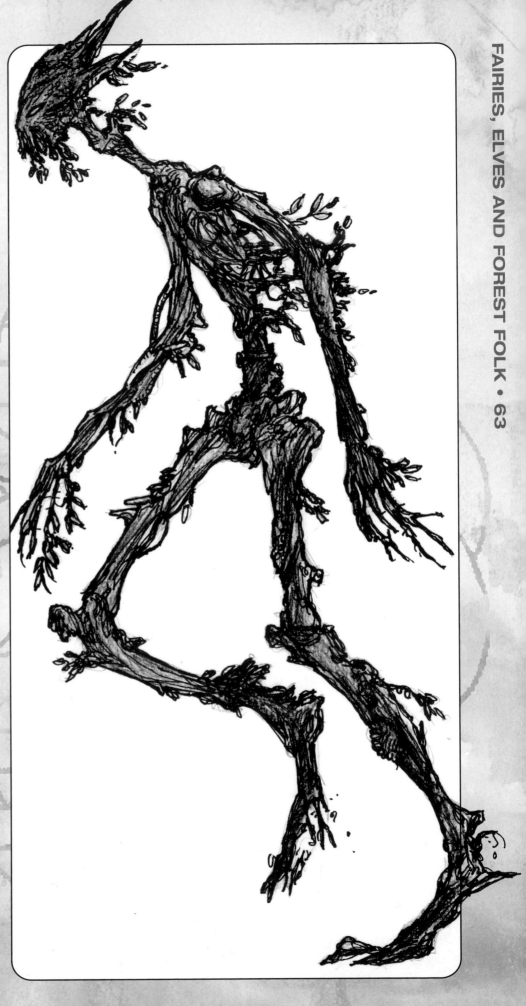

Dryad

This wood spirit is further example of a slim, wispy figure. Like the fairy, he's tall and fragile-looking, but also has particularly extended limbs, especially his neck. Even though he appears to be made from sticks and twigs – complete with small offshoots and leaves – the Dryad resembles an elongated human skeleton. Take a look at the stick-figure image. He may have a tiny rib cage and an inverted bowl-shaped head, but all the major bones and joints of a human skeleton are easy to see here.

This is another example where knowledge of anatomy can help you design and draw a thoroughly convincing fantasy creature.

The wood spirit appears to breaking into a swift trot, leaning slightly forwards, with the weight on his left leg, ready to launch into his next stride. Bits and pieces of foliage flap behind him, giving a further clue to movement and direction.

The final image was created with fineliner outlines and coloured using pencils. Over small areas, good-quality coloured pencils can give a transparent painterly effect.

HOBBITS AND DWARVES

The hobbit ▶

Hobbits are a small race. They're only about half the size of an average human, and their proportions differ a little. Firstly, you will see from this image that he's only about five heads high, as opposed to the seven heads of the human. That means his head appears larger and fatter than the human head. His limbs are shorter and stumpier too.

Draw out the main ovals that make up the figure. As hobbits tend to be rather plump, you can ignore the rib cage and sketch in a large, squashed ovoid shape to represent his whole upper torso. His hips are wide and his neck is almost non-existent.

As his backpack is a major part of the composition of this picture, and indeed, as the weight of it actually alters the balance of the hobbit's stance, you should sketch it in at this stage. Now you can position the arms correctly as he grasps on to the backpack's straps.

You'll notice that the hobbit also has large hands and especially large feet in comparison to a human.

Details ▶

Next, add the facial features. His head is a typical three-quarter view, as you practised earlier in this book. If your drawing is large enough, you can place all the construction lines, bearing in mind that the head will be wider than a human's. As you probably know, hobbits are happy little creatures, so you can draw a smile on his face, his eyebrows raised in amusement.

Add some shape to his legs and arms. Short and thick are the key words here. Note the exaggerated calf muscles and the huge, bulky feet. As the little chap is in a three-quarter pose, you will find that you will need to draw his right foot in a side view and his left foot almost front on. It may take some time to get the hobbit's feet to look like he's standing relaxed and on an even surface, but don't despair as this is one of the most difficult things to draw correctly.

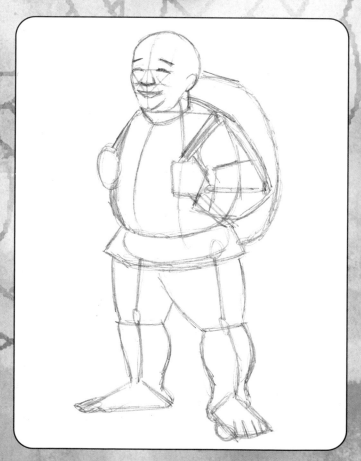

Clothing ▶

Okay, it's time to start adding the fun stuff; some curly hair, a pipe, a split cape, tunic, waistcoat, trousers and an assortment of travelling paraphernalia like saucepans, hunting knife and hip flask. Don't forget the large-buckled belt that always seems to need tightening. Hobbits never wear shoes, though – their feet have developed a calloused sole which negates the need for them.

Take a look at the shapes that the folds of the hobbit's left sleeve have created. The forearm covers the upper arm, making two areas almost square in shape. It's interesting to note how the layers of clothing and accessories lay over each other. You can see nothing of his right arm except his fingers, his backpack straps go over the cape, his cape over his waistcoat which is over his tunic. The hobbit's round belly virtually hides his belt and the bottom of his shirt covers the top of his trousers. Thinking these things through properly really makes a difference when creating an authentic-looking character.

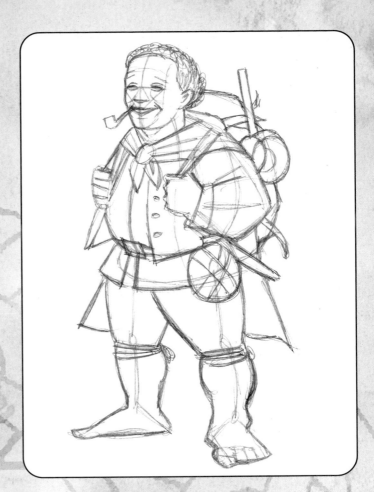

Shading ▶

At this stage, you can trace the main outlines of your drawing onto a fresh piece of thin card. To create an illustration that has a softer, gentler effect, you can use a coloured pencil for the final rendering, in this example, using a rich brown for the outlines.

Tighten and smooth each part of the drawing. Some simple cross-hatching can add shade and shape to the figure. Make sure you vary the width and strength of your line. In this example, compare the heavy line for the large parts of the figure, like the head and arms, to the much lighter, softer lines used for shading. Don't forget that hobbits have very hairy feet – some short, slightly curved strokes will give the right effect. Compare that to the cross-hatch shading on the waistcoat. This kind of shading is something else you don't want to overdo; knowing when to stop is something you always need to be aware of.

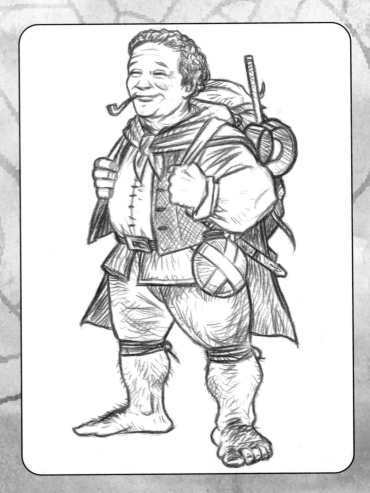

Watercolours ▶

To add colour and shading, use a watercolour wash. Remember not to 'flat colour' everything like a child's colouring book. Leave some areas white to create highlights. This example has been coloured quickly with large brushstrokes, giving a very lively yet soft appearance. You may have noticed that again, a limited palette has been used – mainly brown and flesh tones with a touch of blue for the hobbit's cape and his pots and pans.

To give small areas that need a little colour boost, you can use coloured pencils over the top of the wash to add a little vibrancy. Try using a red or russet pencil over details like the knife sheath or hipflask to give the brown a polished leather look.

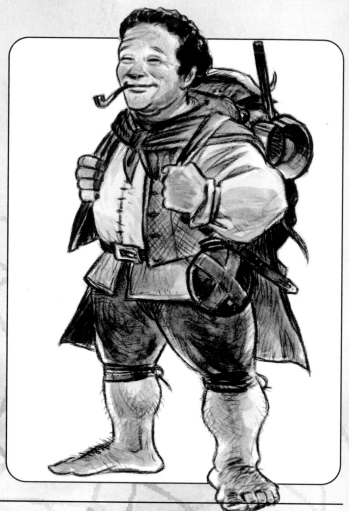

Down on the farm

The average hobbit is more of a rustic, agricultural character than an adventurer. Here are some suggestions for some of the things that might make up his world: a donkey and cart enables the hobbit to transport his crop to market, or maybe he prefers to make his own cider. Either way, it is certain that he likes a pipe. Innocent farm implements like the scythe, pitchfork and pick can also double as weapons, if necessary.

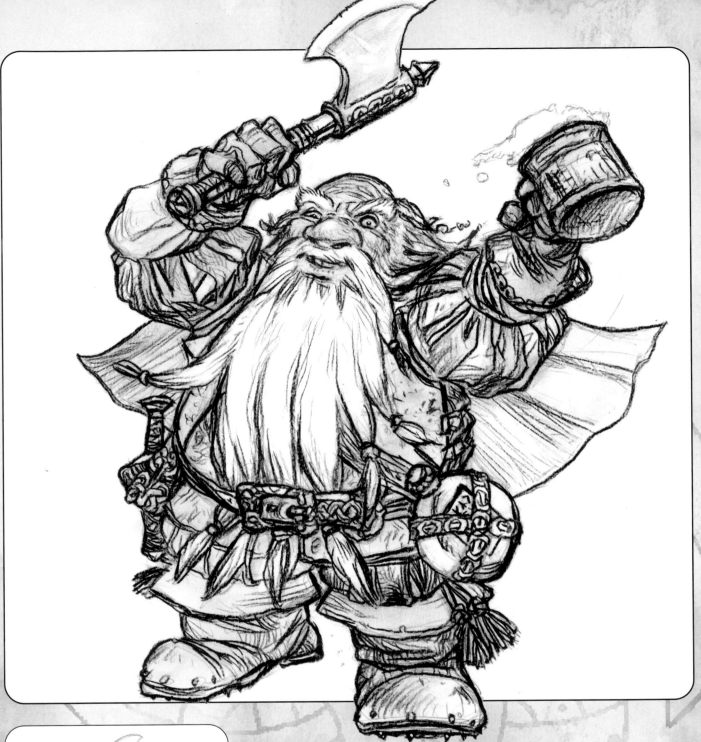

The dwarf

Even stockier than the hobbit is the dwarf. He's barely four heads high and most of his body here is composed of spheres rather than cylinders.

This little chap is obviously enjoying his beer, as well as demonstrating his skill with his axe. Unlike the hobbit, the dwarf wears heavy boots and is especially partial to growing an impressive beard.

Study the composition of the figure and see how the dwarf's cape and huge beard draw the viewer's eye towards the focal part of the image, his face. His arms, held aloft also create a space which virtually 'frames' his head, making this a particularly satisfying and balanced illustration.

The finished drawing has been rendered entirely in pencil, using degrees of shading coupled with a strong outline. Notice the intricate detailing on his belt and axe, reflecting a tradition of dwarfish craftsmanship.

ORCS, OGRES, TROLLS AND GOBLINS

It's time to attempt something a little more sophisticated. This tutorial will show you how to draw a monster – in this case a dopey-looking orc – in an action pose.

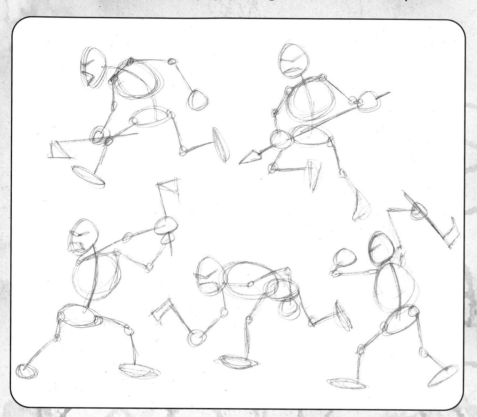

Stick figures

Start by sketching out a number of small stick figures that suggest movement. Even at this early stage, the armature should suggest a heavy body, short arms and legs with a large head and a lumbering gait. He'll probably be carrying a weapon of some sort.

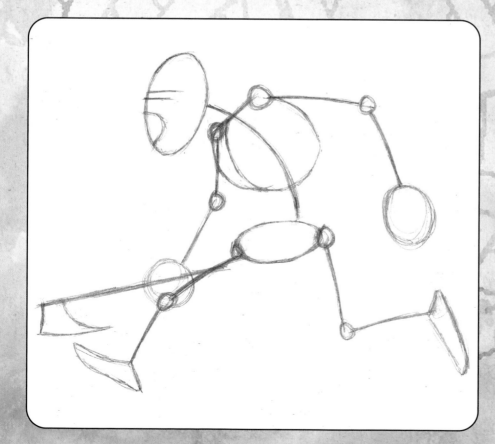

The running orc

Choose the most satisfying stick figure to work up into a finished drawing. You can copy your sketch onto a larger piece of paper or board, but be careful not to lose the immediacy of the drawing – keep your sketch loose and try to retain the movement.

Some artists like to do small 'thumbnail' sketches and then blow up the image (using a photocopier or an art projector), before tracing onto a new sheet.

Figure out exactly where you should place the articulation points of the shoulders, elbows, hips and knees (which are indicated here by small circles).

Three-dimensional drawing ▶

Now it's time to start dressing up the stick figure with three-dimensional cylinders. Notice here how stumpy the orc's limbs are compared to the average human's arms and legs. He also has huge hands but short, fat fingers. His hands hang almost down to his knees, suggesting an ape-like physique. His legs are so short too that his axe is almost dragging along the floor.

His eyes are tightly closed and his mouth is opening in what you can imagine to be a blood-curdling war cry.

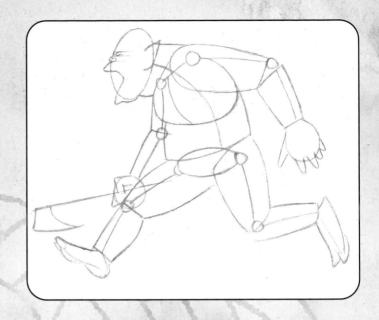

Softening the outlines ▶

The previous stage still looks a little stiff, so soften the outlines of the figure, accentuating his fat torso with a double-chin, drooping chest and a pot belly. You can add some further detail to the face, filling his mouth with huge, rotten pointy teeth. Make sure he has a firm grip on his axe. Note how the joints of his thumb of his right hand bend back on themselves. It's a monster's hand, but still behaves in the same way as a human's even if the proportions are different.

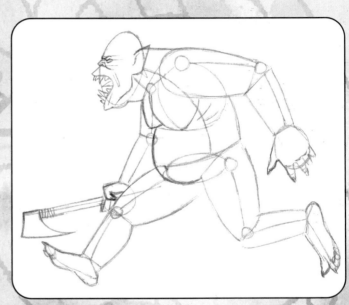

Clothing ▶

It's about time you put some clothes on your orc. Not too many, as he's a carefree kind of guy, but enough to cover his modesty and to make him look a little more war-like. Here, he's wearing a fairly elaborate helmet. It's based on an ancient Greek helmet, like Achilles might have worn. It's got all kinds of neat adornments and details. The flowing mane at the back really helps to suggest movement, as does his loincloth, flapping in the breeze – it's easy to see that the orc is charging forward in an alarming manner.

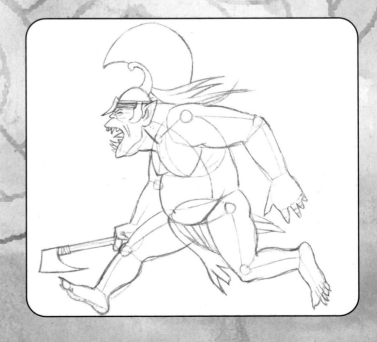

Final stages ▶

Your anatomical knowledge is going to come in handy again in the final stages of rendering our fine monster figure. A few new lines in the right places make the orc look like he's straining every muscle to get wherever he's going. Add small, neat lines around the mouth, neck, hands, forearms, knees and ankles where muscle and bone show through the skin. You can also add guidelines for details on his helmet and some primitive wristbands. Lightly erase all your unwanted construction lines and you can start inking. In this example, a dip pen and sepia-toned ink have been used. Start with the most important, heaviest lines first to get your line 'weight' right and progress onto the finer details with a more delicate line later.

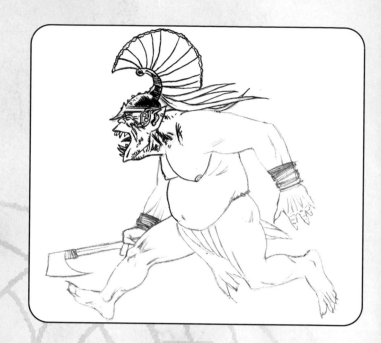

Rendering ▶

This final image has been given a strong outline. Notice that it's not just around the outside of the drawn area, but also continues onto the front of the orc's chest and the lower part of his left arm, among other places. This not only helps to separate the limbs but also gives the impression of depth.

The rendering that has been chosen for shading is of the very short, stabbed variety, with some variation for textures. These short strokes suggest both hairs on the chin, chest and forearm, while other strokes on the belly and legs suggest shape and form. Shading is heavy on the orc's helmet, but sparse elsewhere – be careful not to overdo it, else you may be in danger of ruining your drawing. Knowing when to stop is an art in itself.

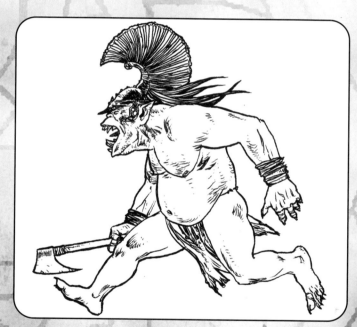

The orc's armoury ▶

You might imagine that the orc's accessories would be rather primitive-looking, and you would be right. Here, you have a selection from any self-respecting orc's armoury, including his swords, shields, spear, axe, mace, club, helmet and necklace. Rough-hewn and tatty, his collection is nonetheless quite scary-looking. Note the human skull 'trophy' decorating the top of his spear and the grisly collection of teeth on his necklace.

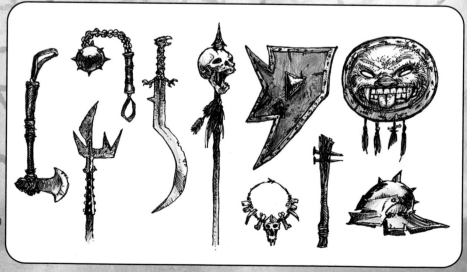

The battle ogre ▶

Now, try to draw this hulking brute. He is known as a battle ogre. Always start with your stick figure, even if you can't see one here. The shapes which make up his figure are all very short, squat and chunky. Study his posture – this ogre is so hunched that his neck appears to protrude from the front of his torso rather than the top of it. He's leaning forwards from the hips and his short fat legs make him look very top-heavy. His long arms and huge hands make him look gorilla-like, but he is a much stockier, more powerful figure.

The ogre's pose is very compact – everything is hunched together. Notice also the foreshortening on the handle of his mace, as well as his right forearm. Work up all the detail you'll need for the inking

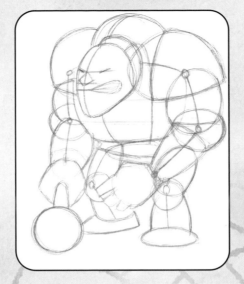

stage. The ogre's armour is covered in short, aggressive-looking spikes which mirror the horns on the top of his head. Notice that the cone-shaped spikes around the edge of the armour are seen as triangles, while the ones seen from above appear as

circles – on his mace there are also three-quarter view versions. Mould his mouth into a sneer, baring his teeth. Figure out how the various segments of the armour overlap each other. Erase everything that you don't need prior to inking.

Heavy inking ▶

To reflect the ogre's heavy physique, why not try to use a heavy-inking technique? Figure out your light direction and place your heaviest blacks first. Don't be frightened to leave white areas adjacent to the black areas, as this suggests a shiny material like polished metal, which is entirely appropriate here.

The small remaining areas can be rendered and shaded with coloured pencils. You can also experiment with applying white pencil over the marker to add an alternative colour transition. If the white pencil from your pencil set doesn't cover too well, there are pencils called 'china markers' which are very effective. Alternatively you can use an opaque paint, like gouache.

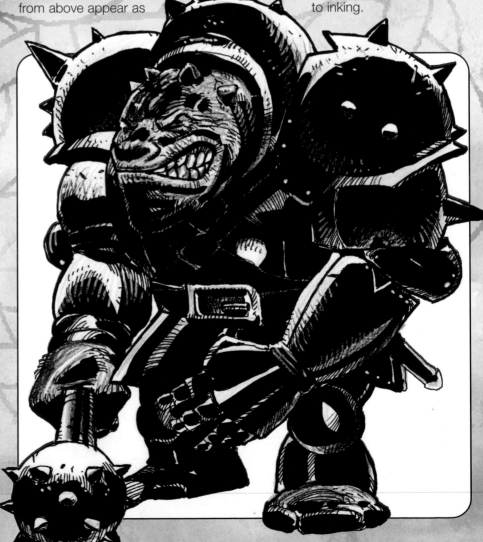

The head of an ogre

▶ This handsome chap is a slightly more humanoid version of the battle ogre, but is still aggressive and dim-witted. An ogre has a wide, heavy-looking head, so rough out the basic shape, this time more like a squashed circle than an oval. Sketch in the centre line, which as you're drawing a three-quarter view will be left of centre, but still following the contour of the imaginary sphere. Mark out eye, nose and mouth lines from the centre line. Being an ogre, the eyes should be much closer to the top of the head, giving the character a small forehead to imply low intelligence.

▶ Once you have the basic shapes looking solid and in proportion, you can start to add a little more definition. Work in features like a snarling mouth, pointy and crooked teeth, a short fat tongue and a boxer's ear.

▶ Build up the brow, nose, eyes and teeth. Add skin folds and creases around the forehead, eyes, cheekbones, mouth and neck. Add further details like the tongue, studs on the armour and hair (not that our ogre has much of it).

▶ If you're going to go ahead and ink this headshot, pick out the lines you want to ink with your brush or pen and trace over them. Note the heavier line around the outline of the character here, including his chin, neck and ear. This helps to add depth and definition to the shape. At this stage, once the ink is dry, you can erase the pencil lines.

▶ You can now add colour. Use transparent media like coloured inks, watercolour or even an acrylic wash. Build up a number of layers of wash to increase the illusion of depth. Remember to leave some areas white to indicate highlights which help to bring the illustration alive. Try to make sure that the direction of the lighting is consistent.

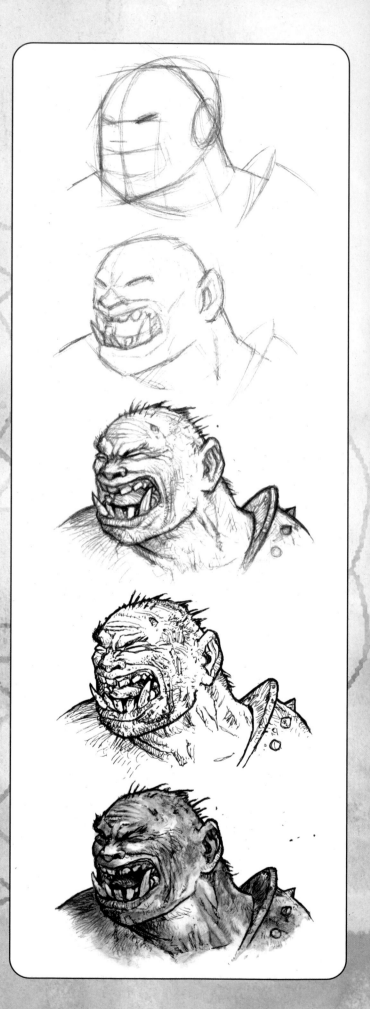

More monstrous heads

Compared to the other archetypes shown in this book, the humanoid monsters of the orc, ogre, troll and goblin varieties have more variation in shape and appearance than any other. Sometimes it's hard to tell your orc from your ogre. Here are some additional examples to inspire you to create your own man-monsters.

The orc in the tin helmet (top) has a part-human, part-animal face, with a huge area between his nose and mouth, a fat protruding bottom lip, upward-pointing tusks, and strange, tiny slanting eyes.

This goblin face (middle left) has hugely distorted features, but retains the essential elements and relationships that a human's face has. But in contrast he has hugely exaggerated ears, beak-like nose and wide mouth. He looks like a nasty little thing, and his bulging eye and curling eyebrow accentuate this.

Trolls spend a lot of time outdoors and this poor chap (middle right) looks like he has moss growing on his head which suggests that he's spent too long in the sun. He has virtually no neck and such a badly stooping posture that his skull barely peeps over his shoulders. Compare the difference in size and shape of his eyes, nose and ears with our previous example.

You can exaggerate your fantasy figures until they become almost cartoon-like. This cave goblin (bottom left) has enormous ears, extraordinarily long fingers and an intense expression and yet he seems to be almost cuddly in comparison to the other goblin. It's probably not advisable to cuddle him, though.

Our final example (bottom right) is a more humanoid creature, although his nose and nostrils owe much to the great ape. His thick neck, bald head and broken teeth together imply a creature of low intelligence, strength and aggression. In other words, he's an ogre.

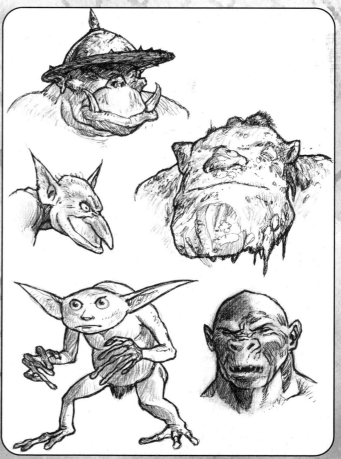

FANTASY ANIMAL SKELETONS

As knowledge of human skeletons is an important consideration when creating humanoid monsters, the underlying bone structure of animals can inform and inspire the creation of fantasy beasts.

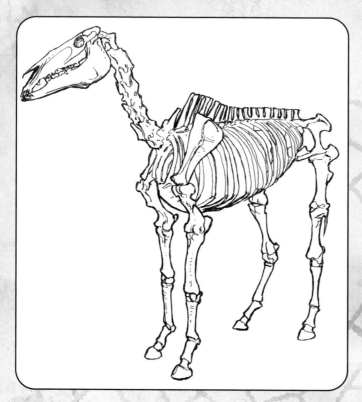

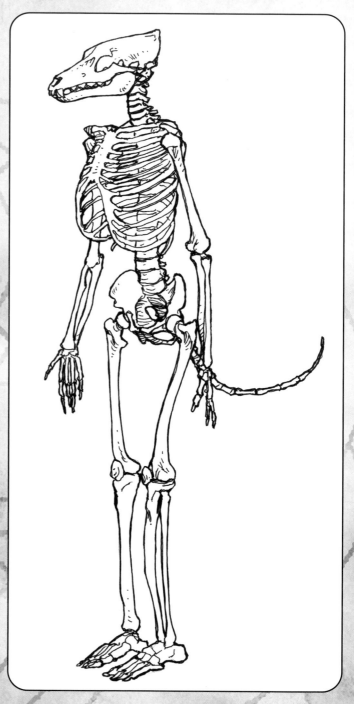

The ghost horse ▲

In the broadest terms, a mammal's skeletal structures are similar to a human's. There is a central spine, ribs, pelvis, legs, neck and head. Other mammals also have other more interesting, non-human features like hooves and horns, and distinctive skulls.

Notice on this skeleton of a horse that the ankle joints are much higher up compared to the human's leg, and indeed has some additional joints in there too.

Studying animal skeletons not only helps you to construct and animate your own illustrations of animals, but also helps you to invent new ones. In designing a convincing-looking minotaur (a man with the head of a bull), or a centaur (a man with the body of a horse), knowledge of their respective skeletal structures will help you imbue your illustrations with credibility. Getting the joints of the legs looking right on a satyr (a human with goat features) would be very difficult without any knowledge of that animal's physique.

▲The werewolf

Here's a great example of a human-animal hybrid: the werewolf. Skeleton-wise, he's essentially the body of a man with a wolf's skull. He'll probably have a larger ribcage too, and of course, he'll have extended fingers and toes to house his menacing claws. The werewolf also has one thing that the man hasn't, and that's an extended tail bone.

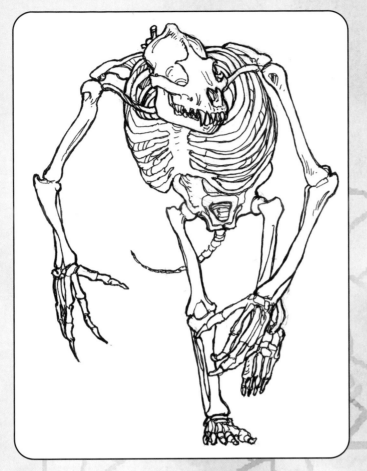

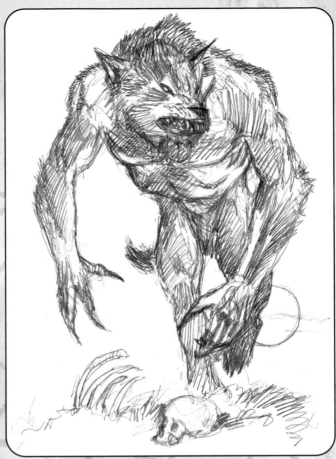

Werewolf position ▲

Here's the werewolf's skeleton in a characteristic lope. As he's half-man, half-beast, his posture should reflect this – half-bent over, almost hunchbacked. In this pose, the creature is running towards the viewer, leaning forwards, weight on his right leg. This illustration is very dynamic because of a little foreshortening – his clawed hands and long arms seem much larger than his legs from our point-of-view.

Werewolf fur ▲

Another big difference about the werewolf in comparison to a man is that he's completely covered in fur, although you can still see his muscular physique beneath. His head is perfectly wolf-like, with eerie pupil-less eyes and sharp-looking teeth, and the tips of his fingers have been extended into nasty-looking claws.
A few blades of grass and the skull of a former victim on the floor help to ground the figure.

The griffon ▶

This fabulous mythical creature has the head and the wings of an eagle seated on top of the body of a lion. Belief in the Griffon originated in the Middle East and found its way into medieval legend and even into modern culture through *Alice In Wonderland* and the *Harry Potter* books.

With some careful groundwork, preparatory sketches and photo reference of lions and eagles, this life-like pencil illustration is so convincing that you could almost believe it was a nature study.

Why don't you try to invent your own animal hybrid and make it utterly convincing?

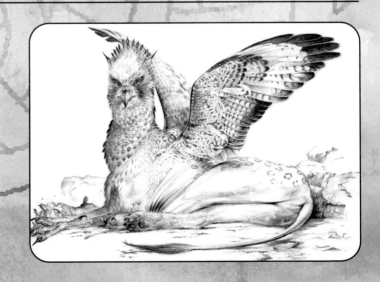

Putting your characters in context
FANTASY WORLDS

Now that you can draw a multitude of different fantasy characters and beings in a variety of poses, it's time to put them into some sort of context. Or, to put it another way, it's time to create the fantasy worlds in which your characters live, love and fight.

Your characters will often suggest a setting. Sorcerers, elves and hobbits all bring to mind a medieval world full of castles and small villages. But maybe you want to create a more exotic oriental location for your samurai warriors, or even a futuristic city with a science-fantasy flavour.

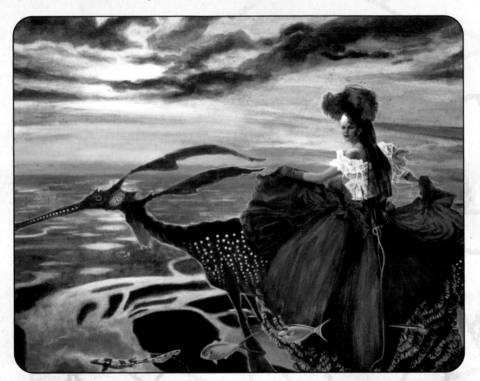

◄ Seascape

This beautiful acrylic painting by James McKay is the sort of image that the budding fantasy artist can aspire to. The spectacular sky and seascape could be somewhere from our world, but the princess riding a fantastical creature in the sky suggests otherwise.

The princess' costume is based on a flamenco dancer's and her mount is based on a something called a sea dragon, which lives in the southern waters of Australia. This curious sea creature only grows to about 18 inches in length, so what you have here is a giant sea dragon, which adds to the fantastical element.

◄ Cityscape

This illustration combines assorted familiar elements from our world in a way that portrays an exotic otherworld. Domed buildings and turban-wearing figures suggest an Arabic flavour and yet the street furniture is more reminiscent of a bustling Japanese city. Other characters filling the streets are dressed in a weird variety of ways and the woman hanging her washing implies a densely populated urban setting. The odd symbols on the signs and flags and the strange camel-like creatures suggest that this is an alien world.

GETTING THINGS IN PERSPECTIVE

The first step in creating a believable, convincing world is to learn the rules of perspective. Yes, it's back to the dull stuff. Except that it's not dull, honestly. In the same way as a little anatomical knowledge can help you build convincing figure drawings, learning perspective can help you create entirely plausible buildings, from tiny farmhouses to complex castles to entire village scenes. You can also use it for interiors, landscapes, or even small objects like books. And here's the good news: it's easy. At least, it's a lot easier than you might think and armed with the following simple rules, some patience and a ruler, you'll be creating convincing backdrops in no time.

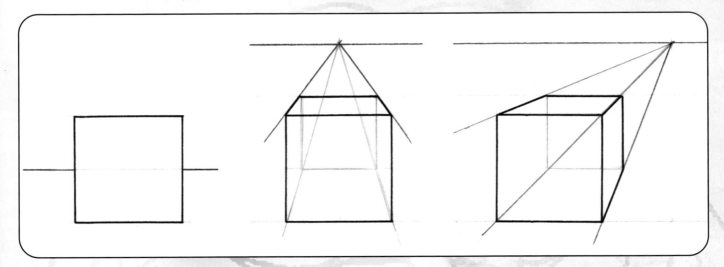

Single-point perspective ▲

Let's take a cube as a simple example. Cubes are, literally, the essential building blocks for all your houses, castles and man-made exterior structures. In the first image, you are looking at your cube head on. It's basically a square. Your 'eye level' (represented by a horizontal line) is right across the middle of the square and you can't see any of the sides.

In the centre image, if you move your eye level 'up' above the cube, you can see the top; the lines of the sides of the cube taper towards the back. It's like you're looking down on the object. If you extend the edges of the cube back until they meet each other, you will find the 'vanishing point', which just so happens to coincide with your eye level. This is also known as the 'horizon line' and is usually drawn horizontally across the page.

In the third image, you're moving your viewpoint along to the right so that you can see one side of the cube as well as the top. Now you have three lines to extend back to the horizon line, and hey presto, they all converge at the vanishing point.

This is still single-point perspective, but it's starting to look more like a proper cube now. Even so, it's not that inspiring, is it? So now try something a little harder.

Two-point perspective ▶

You can see from this example that the cube now has two vanishing points, with three extended lines from each side of the block receding to the horizon line and consequently it looks more like a cube. Remember you're higher than the cube, looking down on it.

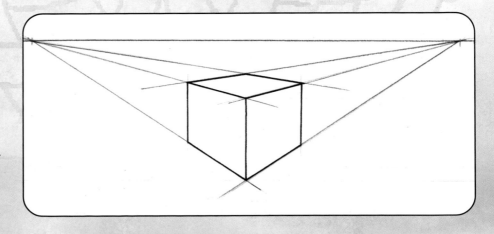

The horizon line ▶

The same rules apply if the cube is floating in the air, and you're looking up at it, above the horizon line. Now you can see the bottom of the cube. The cube has also been rotated slightly so that one side appears shorter than the other, but thanks to the magic of perspective, you still see it as a cube.

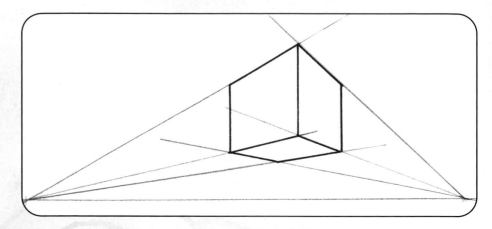

Eye level ▶

If your eye level is somewhere in between the top and the bottom of the square, then it will look something like this, which is how you would view a large building if you were approaching it from a corner.

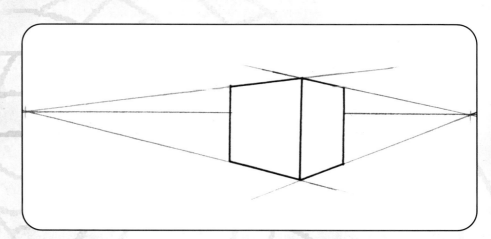

Three-point perspective ▶

Notice that when you're looking up at a tall building, the sides of its walls appear to converge towards the sky? They're pointing to the third vanishing point. Note that this won't be on the horizon line like your other two vanishing points, but an arbitrary point either above or below; way up in the sky in this case.

The closer to the horizon line that you place the third vanishing point, the more dramatic an effect you will create. If you place the third vanishing point below the horizon line, you create an aerial view, as on the following page. You will find that you can't always fit your vanishing points on the paper, but don't worry as you become more familiar with the rule of perspective, you will find you will be able to use your judgement instead of precise measurements.

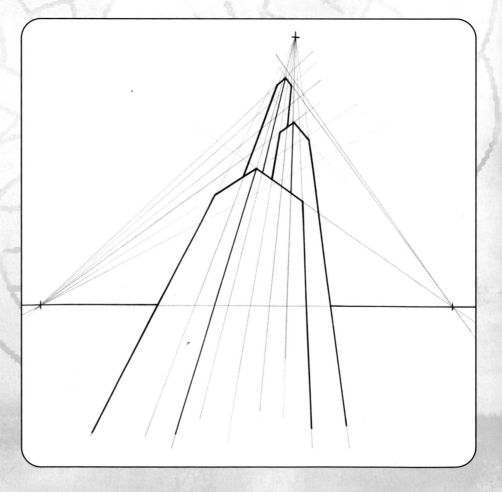

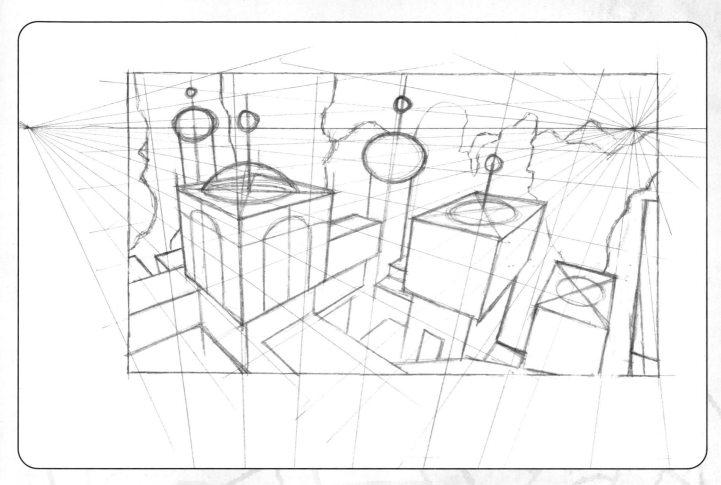

The mystical village ▲

This stunning aerial view of an Arabic-style fantasy city was created with the use of three-point perspective.

Place the horizon line – your eye level – horizontally across the page. The first vanishing point is placed on the left, just out of the picture frame. The second is placed to the right, just within the picture's border. The third and final point is placed way below the horizon line (too low to be included here), to give the impression that you are flying above the village. You may need to tape your paper to a desk and tape another piece below it in order to place the vanishing point correctly from which to draw your construction lines.

Once all the dull working out is done, you can start drawing in all the buildings, houses and towers. Use a variety of sizes, shapes and heights to add interest and dynamism to your illustration. The buildings don't have to be all cubes – here a number of spherical caps and domes to the top of the towers create a far Eastern architectural flavour.

A useful tip for finding the centre of any square or rectangle drawn in perspective is to draw a line from opposite corners – where the cross meets is the centre, as you can see here on the tops of the three towers.

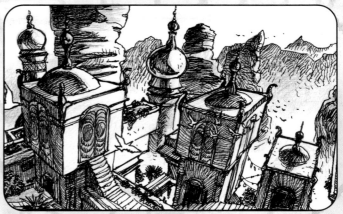

Rendering ▲

Now that all the construction work has been completed, you can finish the illustration in a rendering of your choice. Here, the drawing has been finished in fineliner with blue and ochre tones added by the careful use of coloured pencil. Silhouettes of birds have been included to complete the impression that you are flying over the entire village scene.

The horizon line has vanished in the mist beyond the mountains. Note the direction of the light which suggests that the sun is setting low in the sky to the right of the picture, creating shadows to the left. Combined with the blue colour cast, you are left in no doubt that this is dusk.

CASTLES

Castles are probably the most common type of building in the world of fantasy art. They can be on top of a mountain or floating in the air; castles from which to rescue beautiful princesses.

Basic construction ▶

Most castles are constructed from basic cubes and cylinders. This design comprises four cylinders and two block shapes.

Once you have the basic design down, it's just a matter of patience to add the stonework detail onto a simple grid mapped out onto the surface of the walls. Remember your gridlines should follow the rules of perspective, and also follow the contours of any curved shape. Remember to think about the direction of light.

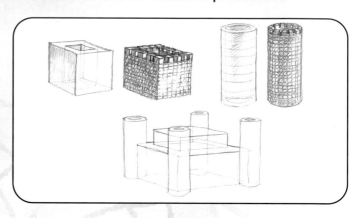

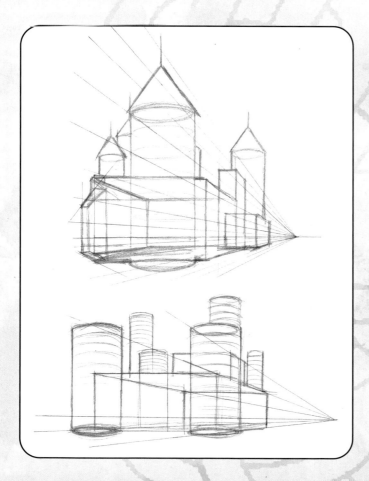

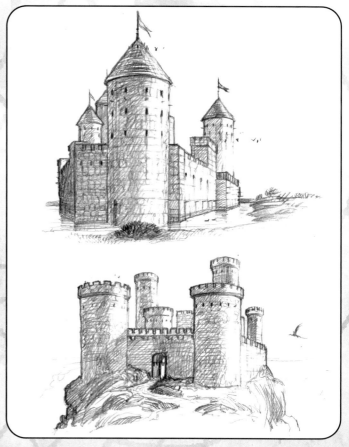

Perspective ▲

Here are two, slightly more complex examples, both are essentially drawn in a single-point perspective. Remember to draw your horizon line first and decide on where your vanishing point will be. Use radiating lines as guides for the straight edges. Tops and bottoms of the walls should be drawn parallel to the horizon line. The more elements you add to your castle design, the more perspective lines you will need to draw, so it's important to keep these precise.

Surface detail ▲

Slit windows and castellations can be added by following your grid pattern and perspective lines. Placing the castle in location (surrounded by a moat or on a mountain top) completes the illusion of reality.

Complicated-looking pictures can always be broken down into a number of smaller, simpler drawings, and with patience and logical thought they can be built up into stunning images like these.

INTERIORS

Perspective can also be used to draw room interiors and objects as well as exteriors. In fact, absolutely anything can be drawn using perspective. Here are two examples of interior perspectives.

Castle corridor ▶

A single-point perspective is an effective technique. All lines radiate out from the centre of the picture, drawing the viewer in.

Try copying this corridor. Simply start with a horizon line and draw lines radiating out from the vanishing point to the border. The overhead beams will be parallel with the horizon line, and the wall beams will be at right angles to it.

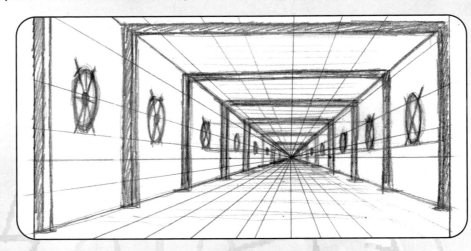

The wizard's study ▶

Once you've mastered that, try a two-point perspective interior, like this wizard's study. Place the horizon line in between ceiling and floor as if you are simply standing in the middle of the room. As our eye level is the same thing as the horizon line, it should be placed towards the top of the picture.

Using your two vanishing points placed beyond either side of the illustration, draw the lines to connect your walls – in this case, where the walls meet the floor. Perspective lines will also enable you to position the hearth, the window, the chair and desk; even the crystal ball stand and the bookcase can be placed in perfect perspective.

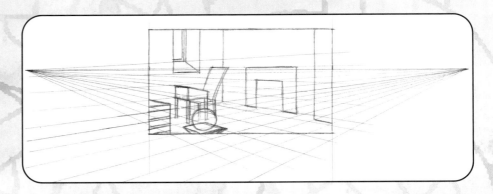

Rendering ▶

Now you can ink over the appropriate lines to create your final illustration and erase your pencil lines. The direction of light here will emanate from the window, so place your shadows accordingly. You can also colour it if you wish.

Hey presto – you have drawn a wizard's study in two-point perspective.

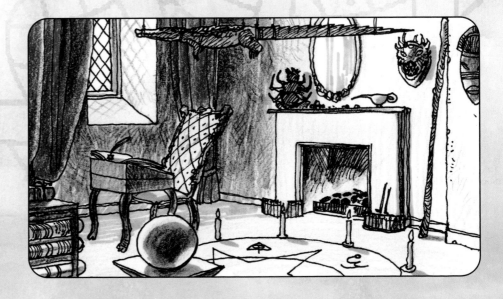

TREES AND LANDSCAPES

The use of exterior landscapes can evoke mood and atmosphere. From thick green forests to dry arid deserts, choosing the right setting is an important part of any illustration you create.

Trees ▶

Trees come in all shapes and sizes. For your fantasy world, you will want to include the more extreme and otherworldly types, but as always, it's better to study and observe trees from the real world in order to make your own creations more credible.

Doodling can help you come up with some exotic ideas for your landscapes. Here are two examples – one with a Japanese flavour, based on a bonsai tree, another with an outlandishly twisted bough. See how easily these trees can be represented with just a few lines.

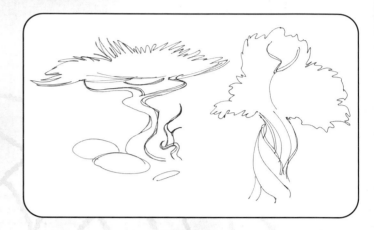

Inking detail ▶

Adding detail with your inking tool can increase the unnatural appearance of your arboreal inventions, although careful observation of real-world trees will add credibility to your illustrations. Both of these trees appear to be compressed with latent energy thanks to the playful and lively underdrawing.

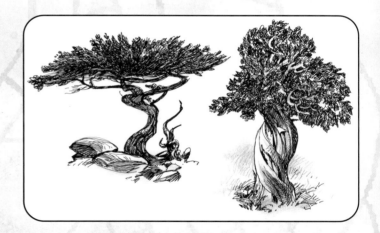

Adding character ▲

This tree is essentially based on a single sweeping 'S' shape. With the addition of a simplified face and the impression of a strong wind, the sketch immediately comes to life.

Rendering ▲

The surface rendering of the leaves, branches and bark is representative of a real tree, but the face and exposed roots suggest that this woody plant is just about to come alive and start walking.

Landscapes ▶

Beasts and birds roam the
savannah. The warm, brown and
orange tones help suggest a hot,
desert landscape, while the animals
themselves imply that this is some-
where on the African continent.
The tree dominates the picture,
but serves to pull the viewer's eye
towards the focal point of the
rhinoceros. This magnificent desert
scene was created using fineliners
and watercolours.

Rural settings ▶

A typically quiet, rural view of the
countryside. The signpost points the
way to the isolated village literally
and compositionally. The flying insect
also draws the viewer's eye towards
the distant buildings. This scene
was created using a dip-pen and
ink wash.

Perspective in landscapes ▶

Strange as it may seem, the rules
of perspective can be applied to
landscapes. Here, a line of trees
recede into the distance towards
a fairytale castle. Look how the
single-point perspective dictates
the position and height of the trees,
and the edges of the road. The
horizon line forms the actual horizon
in this sketch, although in many
illustrations you will find that this
isn't always visible.

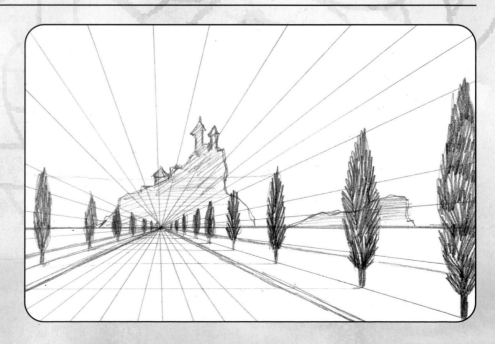

PICTURE COMPOSITION

Composition is another name for the overall design, or layout of your picture. Think about the atmosphere you are trying to create, the angle of view and the framing of the picture. Also think about where the focal point of your picture will be.

It might help you to think in terms of having three 'planes' – the foreground, middle ground and background. You will probably have one figure or more in the foreground, closest to the viewer of the picture. You will probably also have a background of some kind, whether it's the interior walls of a castle or a distant landscape. You may even choose to have some other characters, animals or buildings in the middle distance. These are the elements that you need to arrange into a satisfying, attractive composition. Try to limit your layout to basic, dynamic shapes. Usually, the simpler the design is, the better.

Consider the angle from which the viewer will look at your scene. Could it be more dramatic? Would the picture be improved by moving viewer's eye level to a higher position, looking down, or to a lower position, looking up?

Does the whole design look well-balanced? Do the elements lead the eyes to the focal point, the most important part of your picture? Are any important elements of your picture hidden? Are the proportions of your elements correct? Is your character's body language conveying what you intend? Does the picture suggest the right 'atmosphere'? A lot of these decisions are simply down to the artist's intuition, but a lot can be learnt from studying other artists' work.

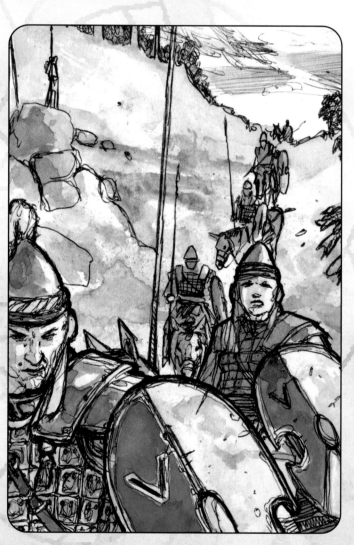

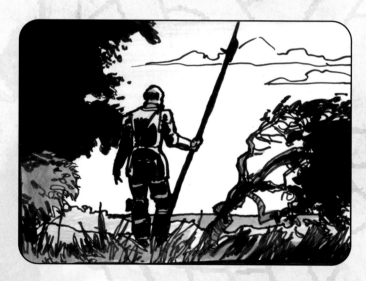

Framing ▲
This illustration (created with markers and coloured pencils) has large areas of black, 'framing' the figure. He's placed about a third of the way from the left. His staff and the windswept tree both draw the eye towards him.

Composition ▲
Here, the two foreground characters are taking up the bottom third of the picture. The 'V' shape of the valley and the other soldiers marching down both help to draw the eye from the top of the picture down to the two soldiers who are the main subject of the composition.

◀ Thumbnails

Before you begin your masterpiece itself, you should always work out the approximate position of the various elements by first sketching out a number of roughs, or 'thumbnail' images.

Experiment with different viewpoints, scale, lighting and other elements. Even quick, simple sketches like these will help you identify the flaws and strengths of your composition. Keep sketching until you find the ideal composition.

◀ Rough sketch

A larger rough sketch of your chosen layout will allow you to figure out the finer points of perspective, lighting and figure drawing.

Only when the composition looks 'right' to you should you progress onto your actual final illustration. If this sketch is accurate and tight enough, you can enlarge (if necessary) and trace onto board for your final rendering.

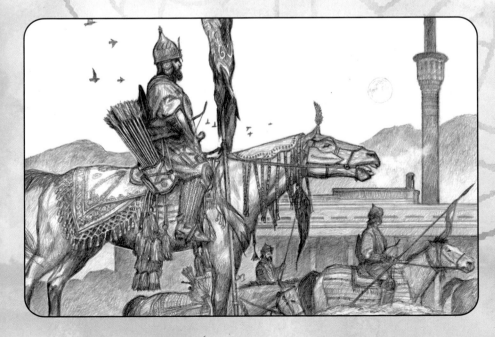

◀ Final piece

Study the composition of the piece, finished in soft pencil. The archer and his steed are in the foreground, taking up about two-thirds of the picture. The horse is a little over half the picture high, but the archer makes the overall shape seem taller.

Other horses and riders are in the middle distance, but these have been carefully placed lower down, as not to interfere with the line of the foreground horse. From the mound of earth just visible bottom right, the viewer assumes that the archer's horse is standing on a higher level.

PUTTING IT ALL TOGETHER

Now you have started to learn some of the skills necessary in order to become a fantasy artist, you can start to put them all together to create your own fantasy illustration.

In this excercise you'll combine figure drawing, action poses, body language, composition, perspective, rendering and colouring techniques.

Rough layout ▶

First of all, you should rough out your proposed layout, bearing in mind that each element should serve the overall composition as a whole, leading the eye to the picture's focal point and providing interest and balance.

This 'thumbnail' rough indicates the placing of the main elements of a composition involving a dragon and sorcerer battling it out on a castle's drawbridge.

Even in this rough stage, the focal point is apparent – the curve of the dragon's body and the dramatic stance of the sorcerer whose staff is attacking the creature both lead the eye to the point of conflict.

Perspective ▶

This is where all your hard work is done, making sure everything is laid out correctly and that everything is in proportion and in perspective. You can still adjust and alter your layout, but be careful not to lose any dynamics or movement when transferring your thumbnail sketch to your art board. Some artists like to enlarge their roughs by art projector or tracing over an enlarged photocopy to retain its essential energy.

Here, the dragon has been enlarged to create an even more dramatic pose, leading the eye into the space between the two duelling characters. The viewpoint has been lowered, making the dragon appear even more imposing and overwhelming.

Notice how the edge of the sorcerer's robe is virtually a continuation of the dragon's 'action line', circling the focal point. The dramatic perspective of the castle background leads the eye towards it.

Surface detail ▶

When you're happy with your perspective, scale and figure work, you can start to etch in the details. Surface detail like the dragon's scales the castle's walls and the figure's clothing can be worked out and sketched in. You may recognise some of the characters involved here from earlier in the book.

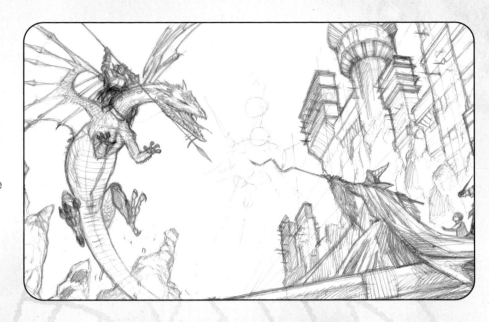

Monochrome wash ▶

As this illustration is going to be completed in acrylic paint, a monochrome wash is going to be applied in order to define light and shade.

A lighting direction should be figured out and shadows indicated. Here, the sun is behind the castle, catching the top of the castle turrets, while a secondary lighting source, from the fireball at the end of the wizard's staff illuminates the underbelly of the dragon.

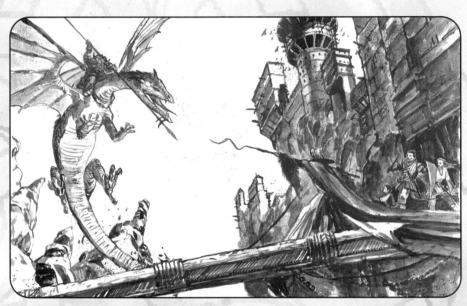

Colour ▶

When you are happy with the tonal balance of your masterpiece, you can start to apply colour. Here, a strong red and blue colour scheme has been applied over the top of the wash. The blue sky provides excellent colour contrast to the red of the dragon's body. White paint has been used to pick out the final highlights on the characters, mountains and drawbridge, and it also adds some sparkle to the wizard's glowing blast.

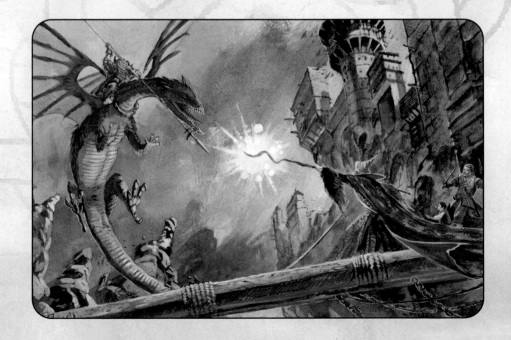

Continuing your quest
KEEPING SKETCHBOOKS

In this book I have tried to impart some very basic knowledge regarding drawing in general, and drawing fantasy figures in particular. But this is just the beginning of your journey. A true artist never stops learning. In these last few pages, I hope to inspire you to tackle greater things.

Develop a sketching habit ▶

Every artist keeps sketchbooks. Most carry a small one around with them all the time for when inspiration strikes. Some carry cameras and other recording devices, because you never know when you will see or hear something interesting.

Sketchbooks aren't intended for publication, or even to be seen by anyone else but the artist. They are for making notes, short sketches, colour studies and for experimentation. Even though you're unlikely to spot an ogre walking along your local street, making a habit of sketching regularly will greatly improve observational skills and, of course, your drawing.

Sketchbooks containing sheets of cartridge paper are available spiral bound or smythe-sewn in a number of different sizes, and if you don't already own one, get one. Pick a cheap one as you will be getting through them quite rapidly.

Get into the habit of drawing anything and everything - your dog sleeping, the trees and plants from your garden, pictures from magazines, things that motivate or challenge you, especially the human figure and all forms of drapery. Go out and about and make sketches at your local coffee house or while on the train.

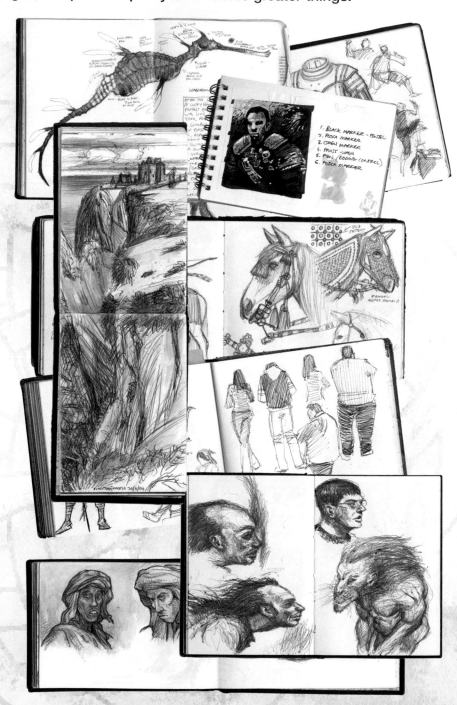

Try doing a number of sketches of the same object from different angles in quick succession. You may be surprised how everyday things can inspire you to create fantasy worlds.

Try using different tools, children's crayons, ballpoint pens, whatever comes to hand.

If you are serious about your art, you can even join a life drawing class at your local college. You can't practise drawing the human body too many times. Even established artists draw from life models to improve and maintain their level of proficiency.

FINDING INSPIRATION

Inspiration for your fantasy drawings can come from just about anywhere. Other fantasy artists' work may motivate you to draw, but you don't simply want to create a facsimile of their work. It's a good exercise to copy pieces of art that you like, if only to figure out how it's been done. You can learn a lot from simply studying and copying other artists' illustrations. But you should never try to pass off your copies as your own work, as it's illegal and morally corrupt.

Source objects ▲

Having pointed that out, studying fantasy art illustrations can put you into the right frame of mind to create your own, original work. You can take someone else's idea one stage further and combine ideas from two or more different sources.

Fantasy movies and television shows can also be a great source of inspiration. Computers can freeze-frame DVDs and print out copies very quickly, which again, is great for absorbing and learning from other artists' designs.

Artists also tend to be fond of big, glossy art books and visual reference books of all kinds as well as bodybuilding magazines for anatomy, and sports magazines for movement and action.

Fantasy novels can also be a great source of inspiration - try to create drawings from the author's verbal descriptions. Mainstream magazines and coffee-table

books, as well as images from every day life from your sketchbook can be used as a basis for fantasy drawings. With a few additions, the model posing for an advertisement for a perfume can become a fantasy sorceress.

Everyday objects like skulls, sculptures, models and toys are excellent for practising your drawing skills.

Sometimes, you will find that you're just not inspired. All creative people have those days. On other days, it may simply take longer to get going. But work at it. Doing something different, like wandering around an art gallery, might trigger your creativity. Try using unfamiliar drawing tools. Like everything else in life, with practice, you will get better at finding your own sources of inspiration.

USING REFERENCES

When you copy illustrations and photos from magazines or books, or even draw objects like action figures or sculptures, you are creating images from other artists' work. This is absolutely fine, and indeed, should be encouraged as exercises for improving your own drawing skills is concerned. But at some point you will want to create fantasy environments entirely of your own making, especially if you intend to make a career as a fantasy artist.

You may be talented enough to pull entire fully-realised compositions out of your head, but most of us aren't so lucky. Reference is an indispensable tool in the artist's cannon. Most commercial artists have a huge 'morgue;' numerous scrapbooks or even whole filing cabinets full of reference culled from magazines, books, photographs, product packaging, just about anything that contains some useful, inspiring or interesting elements.

All kinds of illustrated reference books can be incredibly useful and can often be picked up from second-hand stores very cheaply. Books on history, animals and insects, costumes and landscapes are just a few of the things that you can use to inspire you.

You can buy articulated artist's dolls for anatomical reference, but a good quality 12" action figure can be just as useful at a fraction of the price.

Artists have traditionally used mirrors to reference facial expressions. In the computer age, artists can use a webcam and freeze the image. You may even be able to persuade friends and family to pose for photographs.

Photographic reference, even photographs of your own, should never be copied slavishly. Your job as an artist is to reinterpret the picture in your own eye to create something new and visually appealing. You don't need to copy every wrinkle on the face, every object on the mantelpiece. You should learn to simplify, adjust sizes and proportion, alter layouts and compositions, and allow for things like lens distortions and focusing. You will also want to exaggerate and combine various items in order to create fantasy elements to your picture.

You may just need to know exactly how a shadow would fall across an object, or what clouds do actually look like, but it usually pays off if you take the time and trouble to get these kinds of details right.

◄ Reality check

Here are some snapshots which have been used in the creation of a fantasy illustration. The landscape photo at the top was taken while on holiday in Australia and the horse and rider were snapped at a military re-enactment at Warwick Castle in England – events like these are always useful for taking reference photographs. The rocky mountainscape was another holiday snap, this time from Jordan.

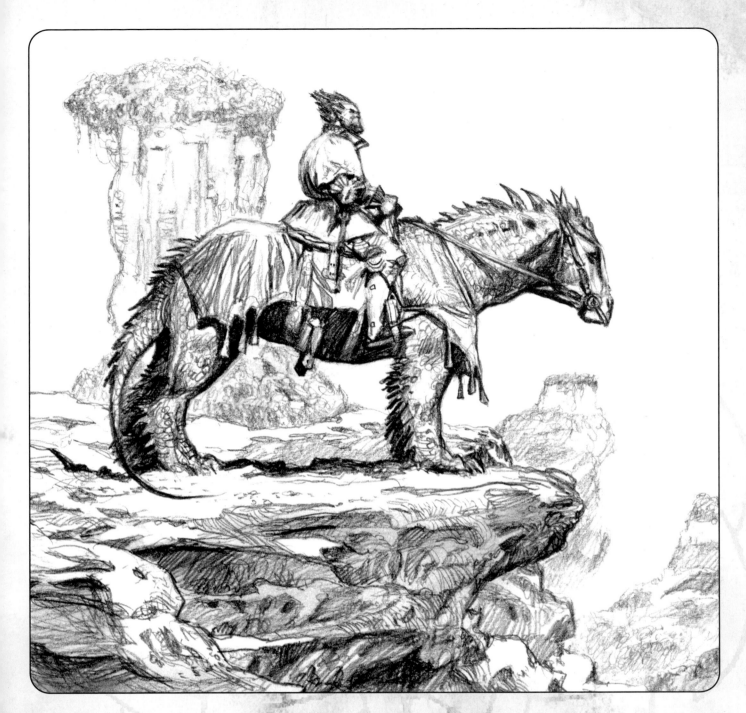

Fantastic illustration ▲

Various elements of this picture have been taken from the photographs to the left – such as the horse and rider's stance and physique, the direction of light which creates the shadows, the shape of the rider's tunic and aspects of the landscape like the cliff formations.

Using these constituent parts as a starting point, various components of the horse have been exaggerated and combined with reptilian elements to create a fantasy beast. The landscape reference has been combined, warped and extruded to create an outrageously fantastic skyline. Everything comes together in a fantasy illustration that is completely convincing.

And finally...

Even though I have stressed the importance of reference and study throughout this book, you should always strive to use your imagination to append and distort reality to create your own distinctive, personal fantasy worlds. Always be bold, larger than life and exaggerate every element of your fantasy illustrations – but remember it's your job to make the incredible look credible, the unbelievable look believable.

There is no 'right' and 'wrong' way to produce your own art, but it pays off big time if you learn the rules before you break them. Look at the world around you, draw, experiment, learn, and above all, have fun.

Index